Why LA? Pourquoi Paris?

Why LA?

Pourquoi PARIS?

An Artistic Pairing of Two Iconic Cities

DIANE RATICAN

illustrations by ERIC GIRIAT & NICK LU

BENNA BOOKS
A Boutique Press for Artists & Writers

www.whylapourquoiparis.com

Published by Benna Books
An imprint of JMD Publishing LLC
www.BennaBooks.com

Distributed by AMMO Books
www.AMMOBooks.com

Library of Congress Control Number: 2013920919
ISBN: 978-0-9911315-0-1
eISBN: 978-0-9911315-1-8

Printed in China

NOTE TO THE READER:
Latitude and Longitude directional numbers
have been added to the images section for your
ease in locating specific points of interest
included in this book.

Magic is believing in yourself, if you can do that, you can make anything happen.

— JOHANN WOLFGANG VON GOETHE

This art book pairing LA and Paris is dedicated to my grandchildren, Brennan, Cooper, Zara, Eden, Cole, Liam, and those yet to come.

And to Peter, my patient and devoted husband, whose love of travel and adventure has always inspired me.

There is so much joy in doing the things you love and creating something that wasn't there before.

Perspective on the pairing of Paris . . .

Time — a European sentiment of a people with a long past, and their very justification and glory — moves more boldly in the new World.

. . . and Los Angeles

Young people, in spite of themselves, sense this. Over here we are contemporary with time, we are brothers of time.
—JORGE LUIS BORGES FROM EVARISTO CARRIEGO

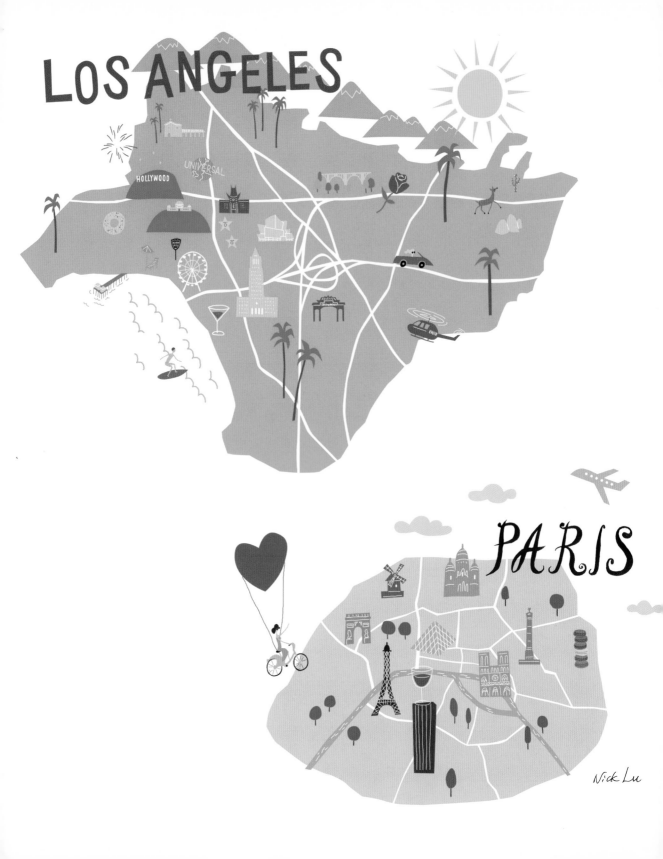

Contents

Foreword

Did you ever have a dream that you wanted to come true, or an idea that you absolutely had to make happen? I did—and it became impossible to ignore. My destiny was shaped when I made a decision to follow my dream. I left my home in Los Angeles and started a business that allowed me to spend as much time as possible immersed in the artistic, creative, magical, and transformative city that is Paris. Dream achieved.

> *If we are always arriving and departing, it is also true that we are eternally anchored. One's destination is never a place but rather a new way of looking at things.* —HENRY MILLER

Los Angeles is unique. It is an eclectic, energetic, and stunningly beautiful place. I have lived in Los Angeles most of my life, and never tire of waking up each day to the sheer natural beauty and dramatic setting of the magnificent sky, the majestic surrounding mountains, the long stretches of beaches, the towering palm trees, and the green open spaces. Springtime's smell of jasmine is intoxicating while winter's citrus trees produce the fleshiest and sweetest of fruits. The glorious sunny weather (most days of the year), the temperate climate, and a bright light that is inspiring and energizing influences every aspect and every minute of life in Los Angeles.

However, like a true Parisian woman who believes she can have the best of both worlds, Los Angeles is my husband and Paris is my lover. There was never a time I did not love Paris. The minute I arrived and got a glimpse of the breathtaking cityscape, I knew I was born to be there. Certainly, it has its own drama and majesty, and the ever-present smells of *pâtisseries* are constant reminders of *le joie de vivre*. The city, like no other I have traveled to,

enables me to experience the privilege of being who I really am. The resulting awareness has brought appreciation and joy to my life in Los Angeles, has created a harmony between my two cities, and has opened doors I didn't know existed.

When [you] fall in love with a city it is for forever, and it is like forever. —TONI MORRISON

This book is about Paris and Los Angeles: the mixing and pairing of yesterday and today, the monumental and the commonplace, landmarks and culture, and its peoples, all coming together to tell, through illustration, the stories of these two iconic cities. It is *my* Los Angeles and *my* Paris as an art, architecture, interior design, fashion, and culture lover with sociology and history degrees that practically force me to constantly seek out, on an analytical level, the unique aspects, down to the most minute details, of every human situation I'm in. These two cities, with all of their differences and similarities, have kept me intrigued and captivated for decades. Knowing them has given me the feeling that I am experiencing something greater than the sum of its parts, and I want to share that overwhelming discovery with you.

Introduction

To love beauty is to see light. —VICTOR HUGO

LA The day I turned sixteen and got my driver's license was the day I realized what it really meant to live in Los Angeles. I could trust in myself—my free spirit was liberated! I could now discover the city's beauty and diversity independently. I lived in West Hollywood at the time, and drove my blue Impala convertible down Sunset Boulevard to the beach. I often re-imagine that moment of my teenage self driving up the Pacific Coast Highway (PCH as the locals call it) with the convertible top down, taking in the beautiful stretches of beaches, quaint piers, surfers along the shoreline, bluffs, and cliffs. I recall thinking that Los Angeles is not monochromatic, but instead is more like a kaleidoscope—a morphing of colors into something complex and beautiful. I felt lucky to live in a city that I would describe as a rainbow of ordered chaos. I will always remember thinking that this city was (and still is) so full of opportunity.

The city's open and enthusiastically outdoor lifestyle is a direct product of its natural environment, which makes a person feel that anything is possible when you have such proximity to every conceivable urban amenity. It is one of the few cities in the world where, within the same day, you have the option to be in the mountains, the desert, the city, or the beach, and can experience unbelievably beautiful sunrises and sunsets. Los Angeles (LA) is ever-changing, constantly reinventing trends of the past with the future in mind. What I find makes LA so appealing is its strong sense of individuality and creative self-expression that is inherent to its DNA; its culture has mastered *laissez-faire* in a way that no other city has.

LA is a massive collection of diverse communities, each with a different feel and story. It is a puzzle of complexity with each community, culture, and demographic as unique pieces

that are forced to fit together. This puzzle's shape continues to be defined and redefined, again and again. The City of Angels, as it is often called, is focused on both the present and the future, while celebrating its past and its heritage. It might be thought of classically, as the *Great Gatsby* of American cities; a figment of its own imagination and a futuristic wonderland. LA is now considered one of the great cities of the world—a global metropolis, blending people of the world in its cosmopolitan matrix.

Nick Lu

Nick Lu

If you are lucky enough to have lived in Paris ... then
wherever you go for the rest of your life, it stays with you,
for Paris is a moveable feast. — ERNEST HEMINGWAY

Paris

Paris is special. When I was eighteen, I spent time in Paris as a university student exploring Europe for the first time, becoming aware of how very beautiful, enchanting, and inspirational the city is with its majestic buildings, elegant boulevards, and colorful neighborhoods. It was difficult for me to leave, even then, a place to which I knew I had to return.

And return, I did—many times and over many years, acquiring a habit and intense love of fashion and design. This resulted in the launch of my own apparel fashion business importing, selling, and distributing French children's designer clothing to upscale retailers in the United States. This venture enabled me to live my dream and be able to actually own an apartment in Paris. It is no exaggeration to say that where I am today is because of where I was then. On each and every visit, Paris always managed to thrill my soul! I am not alone in this feeling. Throughout history, Paris has been a magnet for great writers, artists, designers, and thinkers, who have been attracted to its nurturing and inspirational atmosphere, environment, and culture.

Predominant words most often used to describe Paris are timelessness, light, love, passion and pleasure. Add to these, pride, authenticity, sensuality and elegance and you begin to have an understanding of the multiple facets that give Paris its distinctive personality, and shape the lives of its people.

La vie, c'est Paris! Paris, c'est la vie! — VICTOR HUGO

1 Cityscapes & Landmarks Magnifiques

LA The City of Angels is much more than the stereotypical image of Hollywood glamour, celebrity, and fantasy. The real Los Angeles is a large, diversified metropolitan area that has traded urban centralization for suburban sprawl. LA is immense. The city is home to almost four million people, the second largest urban area in the nation. And, greater LA County has more than ten million residents, making it the most populous county in the United States. Today, Los Angeles is made up of eighty-eight districts and neighborhoods, each with its own distinctive character, creating a mosaic of culture, customs, and charm. This diversity spreads its influence across a metropolitan area of 469 square miles and encompasses 75 miles of coastline, vast valleys, and the foothills of four mountain ranges in the surrounding area.

It is somewhat daunting to describe how LA is organized. One by one, the main localities are cast out from the downtown center in all directions. The sections include East LA, South LA, the Harbor, Wilshire, the Westside (which includes Beverly Hills, Culver City, Bel Air, Westwood, and Brentwood), the beach communities (Venice, Santa Monica, and Malibu), greater Hollywood (Los Feliz, Silver Lake, and West Hollywood), the sprawling San Fernando Valley, and the San Gabriel Valley (which includes the city of Pasadena). The city's rich cultural heritage and character is reflected in its population mix of Caucasians, Latinos, Asians, and African Americans.

Despite the city's size and incongruous shape, there is still a definitive cityscape. And like its people, the individual architectural styles throughout the city convey an eclectic feeling and reflect its diversity. It begins with the adobe archways and Mission-style towers of Olvera Street, at the historic center of Los Angeles, in what is now Downtown. It is there that El Pueblo de la Reyna de Los Ángeles (The Town of the Queen of Angels) was founded in 1781 by a diverse group of forty-four settlers, including colonists from Mexican, French, Italian, and Chinese heritages. Olvera Street remains an authentic Mexican marketplace with cobblestone-lined walkways, unchanged for decades. It shouldn't be a surprise then that the city's diverse beginnings led to an exponentially diverse future. Now in the twenty-first century, the City of Angels is a world-class city whose inhabitants come from more than 140 countries. Though English and Spanish are the predominant languages spoken in LA, more than eighty languages and a variety of accents can be heard on the streets.

Downtown has been a playground for architects since the city's inception. Some of the city's most important landmarks are located in this historic and evolving urban hub. The historic Los Angeles City Hall, whose Art Deco style once dominated the skyline, opened in 1928 and was the city's tallest building until the 1960s. Built in 1926, the Los Angeles Central Library is respected by Angelenos for its Modernist Beaux Arts and Art Deco style, and its collection of six million books, periodicals, documents, resources, and artwork. Downtown also serves as home to several ethnic enclaves, including the pagodas of Chinatown and Little Tokyo. The Cathedral of Our Lady of the Angels, an imposing contemporary landmark built in 2002 by José Rafael Moneo, inspires serenity and reflection. The Walt Disney Concert Hall, of Frank Gehry's design, is home to the LA Philharmonic. In addition to its spectacular architectural stainless steel design, the Hall is considered to be an acoustically superior venue. These recently built landmarks, inspired by modern and contemporary art, exhibit harder edges and angles that come together to form a unique composition and a beautiful juxtaposition to the older landmarks.

Today, Downtown LA's defining skyscraper is the seventy-three-story US Bank Tower, designed by the firm of I. M. Pei, a Chinese American architect often called the master of modern architecture. A recent renaissance to reconfigure urban space in Downtown Los Angeles is evidenced by the opening of the Staples Center, a sports and concert venue; LA Live, a food, film, and music entertainment complex; the beautifully landscaped twelve-acre Grand Park; art galleries; renovated bars; restored hotels and lofts; and incredibly unique storefronts.

"The Stack" is still a modern marvel: It's the first four-level freeway interchange in the

world and is made completely of bridges over the Los Angeles River (somewhat a misnomer, it was converted into a flood channel between 1938 and 1960). Urban planners used the blueprints of this freeway design in nearly every major US city thereafter.

Just south of Downtown, off the beaten path, are the spectacular Watts Towers, created by Simon Rhodia. These masterpieces of tile, glass, pottery, and shells took thirty years to complete, and finally came to fruition in 1954. The Towers are visual symbols of the spirit of freedom and individuality that defines LA.

Lying west of Downtown is Culver City, one of LA's many Cinderella stories. Once purely industrial, this area has been reinvented into a media and business hotspot, attracting upscale restaurants and galleries. This may be best represented by the compelling architectural design of the Samitaur Tower, completed in 2010. The eye-catching structure symbolizes the area's renewal while offering great views of the city. Culver City is also home to Sony Pictures and Culver Studios, where many movie classics have been filmed, reflecting the innovation and creativity of the area.

The famous Hollywood sign, the city's cultural icon, was erected in 1923 on the top of Mount Lee, and can be spotted for miles. High atop the hillside, lying above the cool, edgy communities of Silver Lake and Los Feliz, is the famous Griffith Park Observatory (1935). This is another LA favorite and Art Deco masterpiece. The Observatory is a great place to see the stars (the real ones), and offers a spectacular view of the city as well.

The beautiful community of Pasadena, where I live, is a mix of old -fashioned charm and contemporary appeal. It boasts panoramic mountain views, is a short eight mile drive down the city's first freeway from Downtown and is home to the world-famous annual New Year's Day Tournament of Roses Parade and Rose Bowl game. Nearby, the majestic Colorado Street Bridge, built in 1913 in the Beaux-Arts style runs high above the Arroyo Seco canyon, a popular hiking and recreation area.

In 1905, developer Abbot Kinney sought to recreate the look of Venice, Italy, in Los Angeles by building a series of canals. He even called the area Venice Beach, and today, beautiful homes line the waterways and the area is a great place to walk around. The bridges crossing over the Venice canals offer a romantic view of the recently rebuilt area.

In LA, people live mostly in individual homes (many with swimming pools), as compared with cities like Paris and New York where residents more often live in apartments. For Angelenos, owning a home is part of the American dream. They spend a lot of time in their homes and are deeply vested in what their homes look like. People express themselves

through how they live and want their homes to be as unique as they are. You'll find a variety of décor along every street.

Experiences that are truly unique to Los Angeles include watching dolphins and surfers off the coast of Malibu, meeting up with incognito celebrities at trendy cafés and restaurants, driving through the chaparral-saturated Santa Monica mountains along Mulholland Drive's century-old oak trees, enjoying panoramic views by day, and watching the city shimmer in a mesmerizing grid of lights by night.

It wouldn't be LA without the towering palm trees. The tall Mexican fan palms line many of the streets of the city and are a symbol of LA's lush, sun-soaked lifestyle. They serve as constant reminders of the wonderful climate and create quiet harmony with nature. The utility poles that stand nearby, tall throughout the city's landscape, present themselves like sculptures set against the expansive sky, and create a beautiful feeling that everything is connected.

But what is history? An echo of the past in the future; a reflex from the future on the past. —VICTOR HUGO

Paris is always a good idea. — AUDREY HEPBURN,
as Sabrina in the film "Sabrina"

Paris

The City of Light has been written about, painted, and photographed more than any other city on earth, and for good reason. The incredible architecture of Paris comes together, in an almost mystical way, to form an ordered whole. The city's buildings, parks, boulevards, monuments, and bridges, as well as its picturesque side streets, all exploit natural light—the silvers of dawn, the clarity of noon, the vermilions of sunset, and the magical softness of *l'heure bleue*. It is this quality of light that makes Paris irresistible. Paris has justly been called the City of Light because light is one of the magical manifestations of its dazzling physical beauty, and a metaphor for its eternally luminous spirit. *La Ville-Lumière* also reflects the city's fame as a center for education and ideas during the Age of Enlightenment.

Paris is a world unto itself.

Contemporary Paris is walled in, encircled by its ring road, the Périphérique highway. The succession of walls that were gradually transformed throughout the centuries created a spiraling city, which grew out from the Île de la Cité. It is on this small island that the first Parisians, the Parisii of Celtic origin, were conquered in 52 B.C. by Roman invaders who named the city Lutetia. In the eleventh century, the Capetian dynasty made Paris the political and commercial center of France, and development of the city began. During the Renaissance, under the rule of Francis I, Paris was enriched with new buildings, monuments, and works of art that started to shape the city's splendor.

Grace and dynamism are found in the astonishing architectural and cultural diversity of Paris. Only a few blocks separate the twelfth-century Gothic grandeur of the Cathedral of Notre-Dame on the Île de la Cité from the Centre Pompidou's twentieth-century modern

eccentricity in Beaubourg. A walk from the Arc de Triomphe, commissioned in 1806 by Napoleon to celebrate his victories, then along the Champs-Élysées, passing the eighteenth-century Place de la Concorde, through the beautiful Tuileries Garden, originally built around 1564, to the Louvre, which dates from the fourteenth century, is quite a stroll through history. The 1,063-foot tall Eiffel Tower (or Tour Eiffel, in French), the most visible structure in Paris, is the city's most visited landmark—and the iconic symbol of Paris. It was constructed in 1889, in just 26 months, for the 100-year celebration of the French Revolution and the Exposition Universelle (World's Fair). Lying in its shadow is the solemn and beautiful Hôtel des Invalides, an seventeenth century masterpiece of Baroque architecture and the final resting place of Napoleon. Perched on a hilltop high above Montmartre stands the Basilique du Sacré Cœur, completed in 1914 and visible from most parts of the city. The view of, and from, this landmark is spectacular.

Paris today, with its weave of narrow streets and broad boulevards, was redesigned between 1853 and 1870, in just seventeen years, by Baron Haussmann under the rule of Napoleon III, who tore down and rebuilt entire sections of the city. The incredible Palais Garnier opera house (1875), the famous Gare du Nord train station, and the beautiful Hôtel de Ville (City Hall), were built during that period, as were the expansive parks and gardens of the Bois de Boulogne and Bois de Vincennes, which flank the city and add enduring beauty. The apartment buildings Haussmann designed remain the Parisian standard. In 1902, the façades and roof structures had to be aligned with the city's height limit of eight stories, giving the buildings the harmony we associate with them today. The beautiful and ordered rooftops of Paris, many fashioned in the characteristic double-pitched mansard style, take on a poetic and dream-like quality. Kiosks, lampposts, and Métro stations dot the streets and reflect an elegant and eccentric character.

The architecture of Paris has been influenced over the years by the different architectural styles of different historical periods, but always with a great deal of planning and thought. The blending of the past and the modern in Paris has mystical characteristics. There is a civilized balance between protecting the structure of what has gone before, and embracing the new and avant-garde. From an art perspective, the repetition of patterns and motifs and the rhythm of details present in the Haussmannian buildings in Paris suggests a feeling of being lost in a Matisse painting.

Haussmann is probably one of the most enduring and successful city planners the world has ever known. Paris was transformed into a modern city, capable of coping with and

adapting to the demands of the twentieth and twenty-first centuries, with regards to transportation, sanitation, illumination, population growth, and every kind of necessary urban service. After World Wars I and II, it was decided that Paris would modernize and expand in a way that would balance preservation and growth. The Tour Montparnasse, completed in 1973, was the city's first skyscraper. At 689 feet it made a very dramatic statement in the middle of low-rise Paris. Now back in vogue with Parisians, the restaurant and observation deck boast a fantastic view of the city. After this, skyscrapers were built in La Défense, a futuristic suburb to the west of the city. The landmark, La Grande Arche de la Défense (1989), created by Johan Otto von Spreckelsen, fixed this sector in the minds of Parisians, making it possible for Paris to grow while keeping the old city pristine. Set on the banks of the Seine is the Bibliothèque François Mitterrand (or the Bibliothèque nationale de France), which opened in 1998. It is composed of four giant glass towers designed to resemble open books. It stands as a testament to the bold vision that Mitterand, France's longest-serving President, had for the city.

Paris is a vertical city, dense with a large urban core. Today it is home to more than two million residents in the urban area, and over ten million in the greater metro area, making it one of the most densely populated cities in the world. (Is it a coincidence that the populations of greater Paris and extended Los Angeles are nearly the same?) Housing in Paris is primarily apartment-based, with apartments tending to be small and expensive, depending on the area or location. The style is not flashy, but it is elegant and refined, be it modern or traditional. The city's twenty different arrondissements (administrative areas) begin with the first, in the heart of the city, move clockwise in two full circles, and end with the twentieth. Each arrondissement has its own characteristics reflecting the diversity of the people of Paris. At least twenty percent of the population are first-generation immigrants. Today, Parisians tend to have a higher than average income and a younger median age as compared to the rest of France, making it an attractive city in which to live, work or visit. Paris is indeed a city that draws people seeking better futures.

Paris is physically divided by the River Seine, with its tree-shaded *quai*s, *Bateaux Mouches*, and elegant bridges like the Pont Neuf (the oldest bridge in the city). Le Rive Droite (the Right Bank) is the glittering heart of the city, with its monumental buildings, expensive hotels and restaurants, and glamorous shops. Le Marais, an old residential area with lots of character, is now chic and trendy. Le Rive Gauche (the Left Bank) is still preeminently the University and Latin Quarter, where you will find offices, banks, libraries, and several significant churches and temples.

Each area has its own discernible character and atmosphere, which is reflected in the streets and the people. I find the special charm of Paris in its distinctive and changing neighborhoods, its small streets, its carefully designed squares and parks, the colors and intoxicating aromas of its flowers, and many fortuitous discoveries. In order to really know Paris, one has to walk through every part, and in every season. Paris is enchanting, where something wonderful is always about to happen.

Paris is a world meant to be seen by the walker alone, for only the pace of strolling can take in all the rich (if muted) detail. — EDMUND WHITE

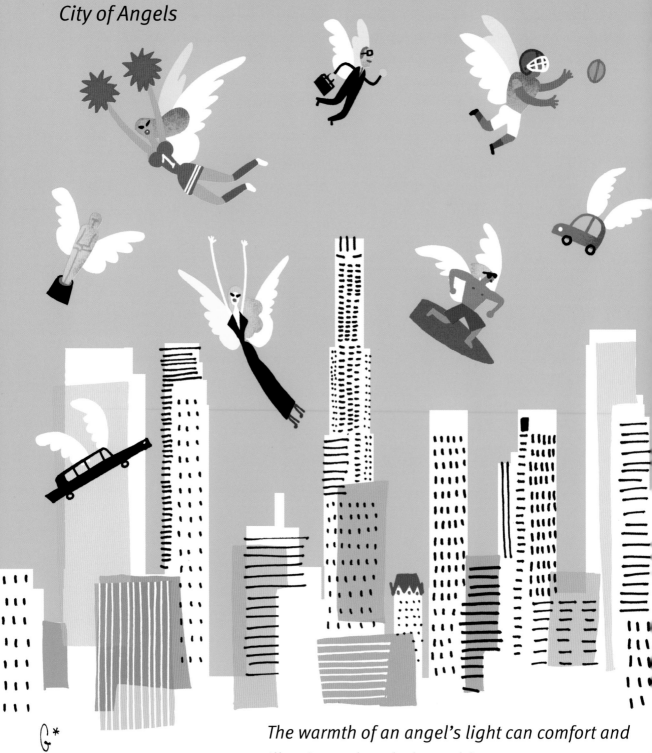

AKA

City of Angels

The warmth of an angel's light can comfort and illuminate the whole world. —KAREN GOLDMAN

La Ville-Lumière

G*

Olvera Street (La Placita Church), 1822

A city embodies the dreams, culture,
and vision of its people, both past and present.

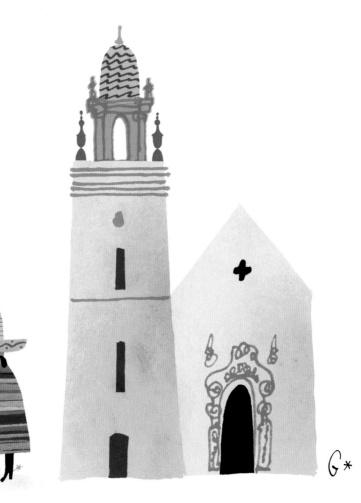

34.0570, -118.2390

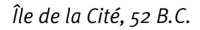
Île de la Cité, 52 B.C.

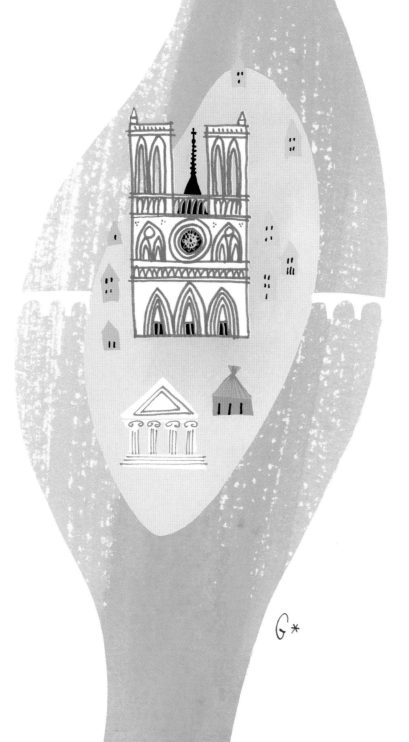

48.8540, 2.3470

Hollywood Sign, 1923

Mulholland Dr
7500 W

HOLLYWOOD

*The remarkable thing is that in a
city crowded with people, a land-
mark is easily remembered.*

34.1341, -118.3216

G*

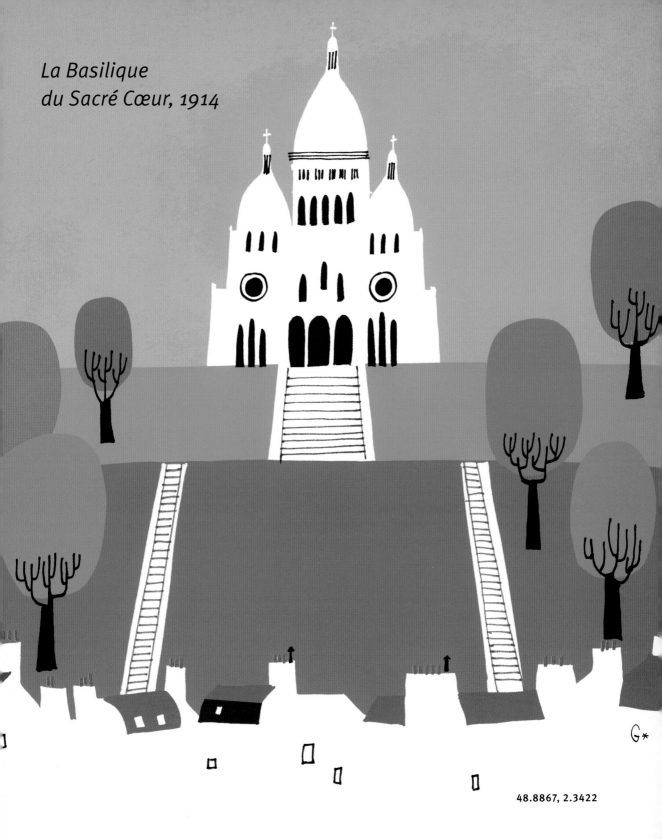

La Basilique
du Sacré Cœur, 1914

G*

48.8867, 2.3422

TOWERS

Watts Towers, 1921–1954

33.9386, -118.2411

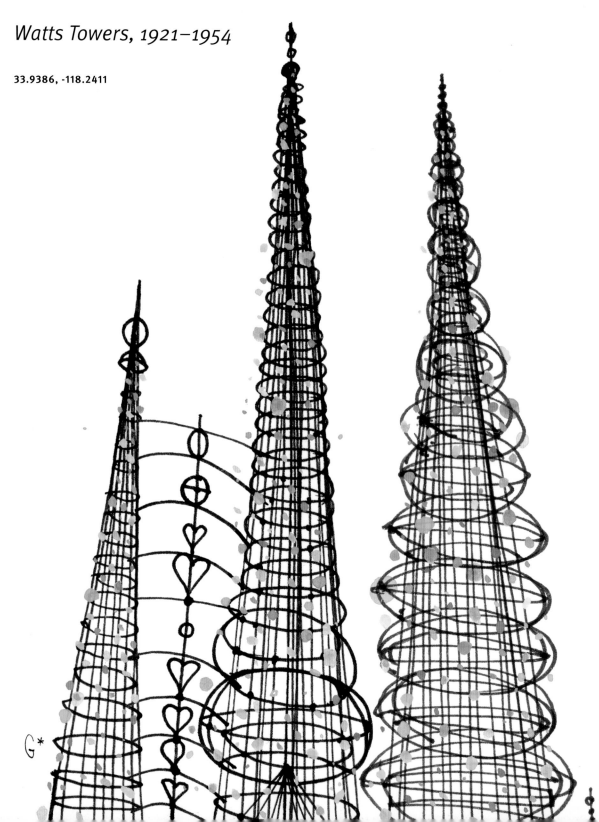

Tour Eiffel, 1889

*Architecture at its visionary
best engages, exhilarates,
and inspires.*
— FRED A. BERNSTEIN

G*

48.8584, 2.2949

Swimming Pools

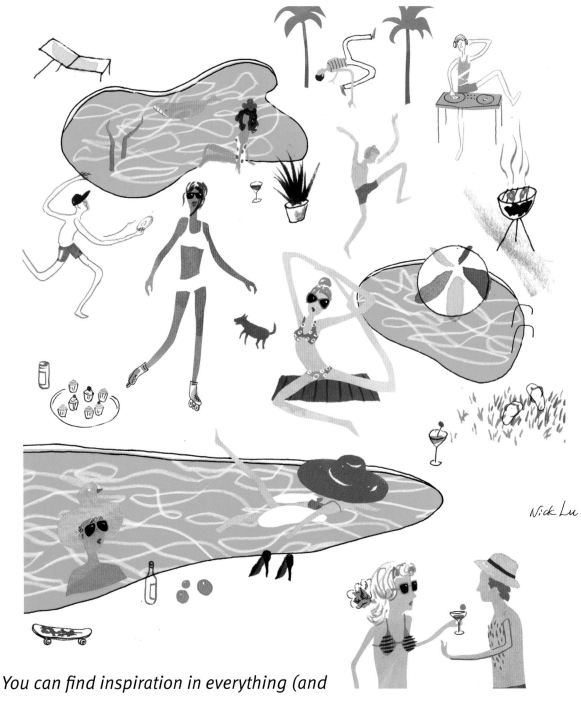

You can find inspiration in everything (and if you can't, look again). —PAUL SMITH

Les Toits de Paris

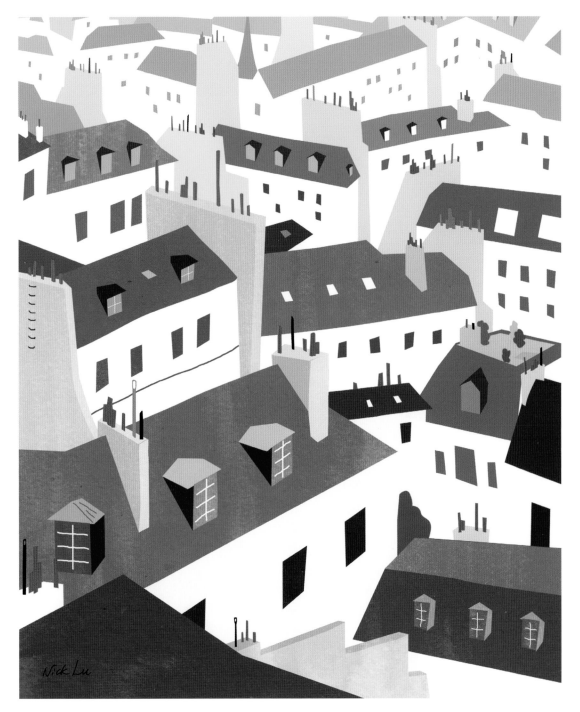

LA City Hall, 1928

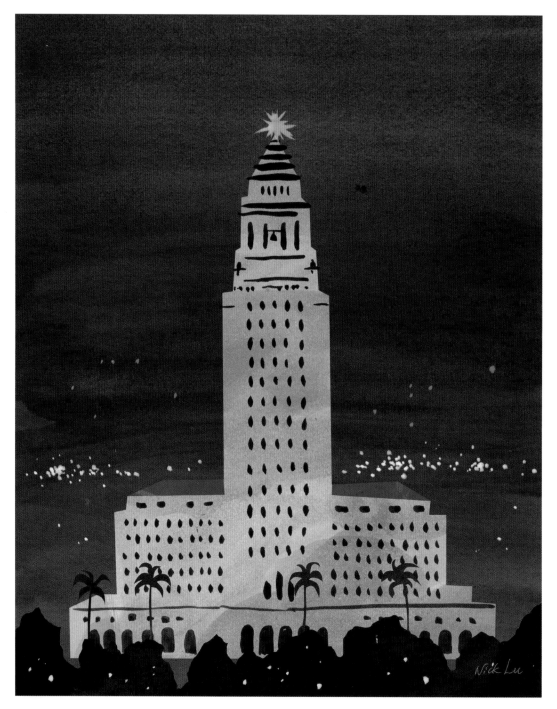

34.0543, -118.2430

Hôtel de Ville, 1882

The best way to predict the future is to create it. —PETER DRUCKER

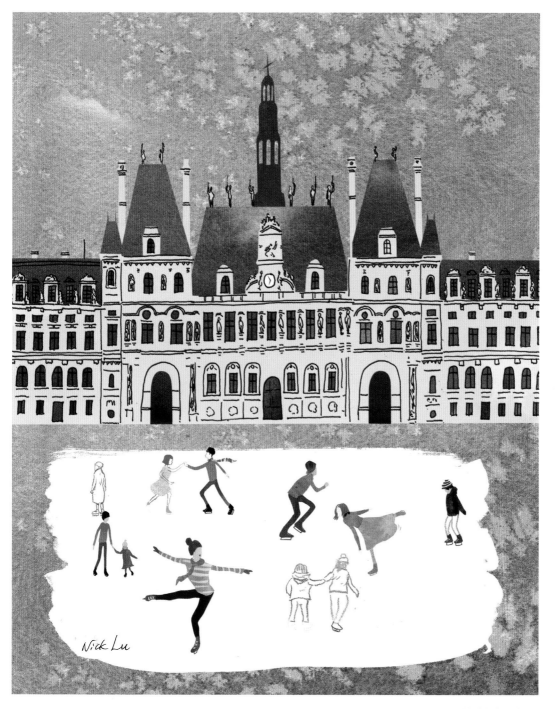

48.8570, 2.3510

US Bank Tower, 1989

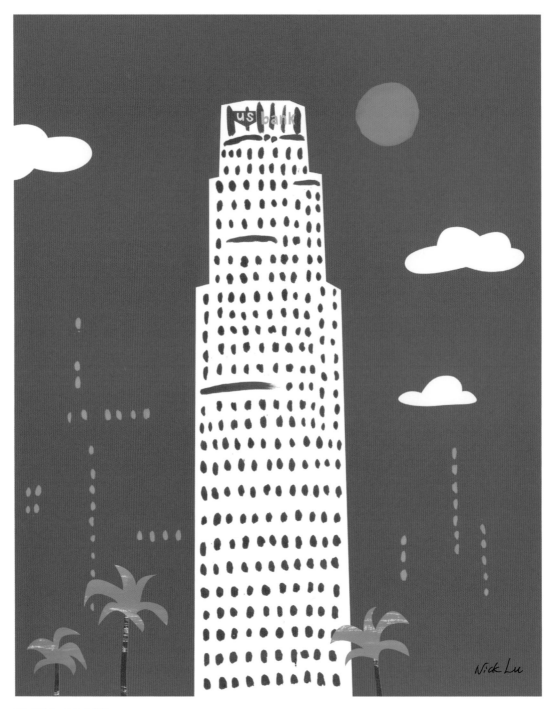

34.0510, -118.2550

Tour Montparnasse, 1973

An architect is the builder of dreams.

Nick Lu

948.8430, 2.3220

Arches

Arches are portals of discovery.

Arc de Triomphe, 1836

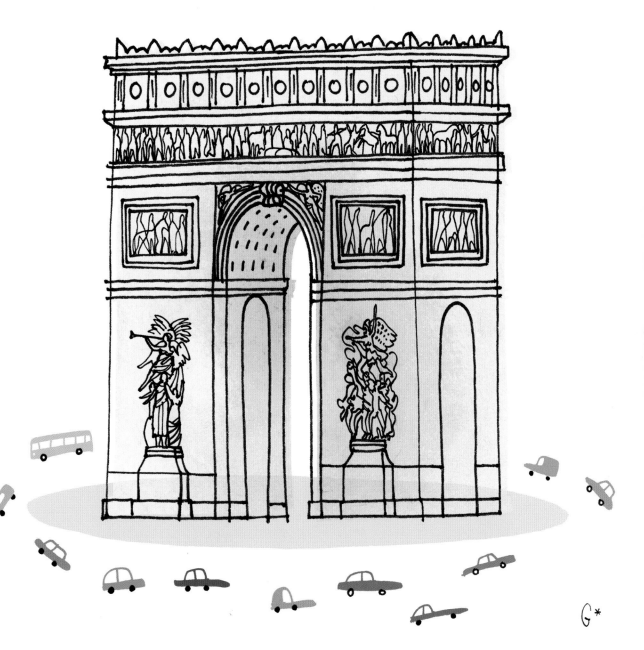

Cathedral of Our Lady of the Angels, 2002

*Mankind was never so happily
inspired as when it made a cathedral.*
—ROBERT LOUIS STEVENSON

34.0570, -118.2450

Cathédrale Notre-Dame de Paris, 1163–1345

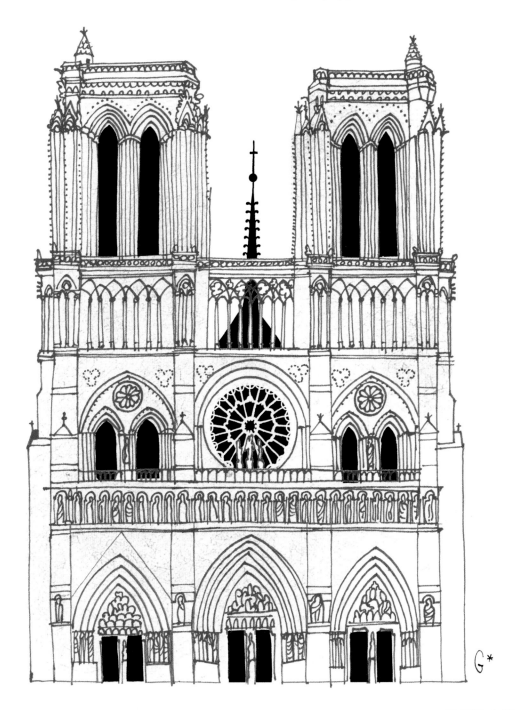

48.8530, 2.3500

Walt Disney Concert Hall, 2003

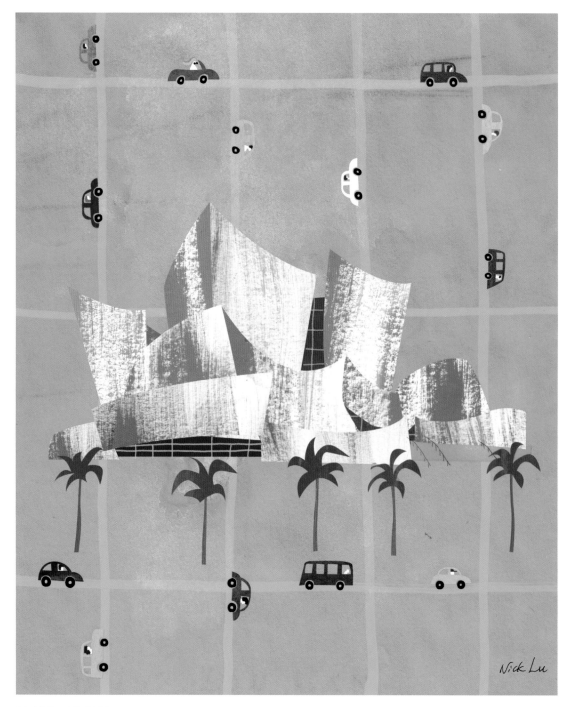

34.0555, -118.2490

Palais Garnier, 1875

I call architecture frozen music.

—JOHANN WOLFGANG VON GOETHE

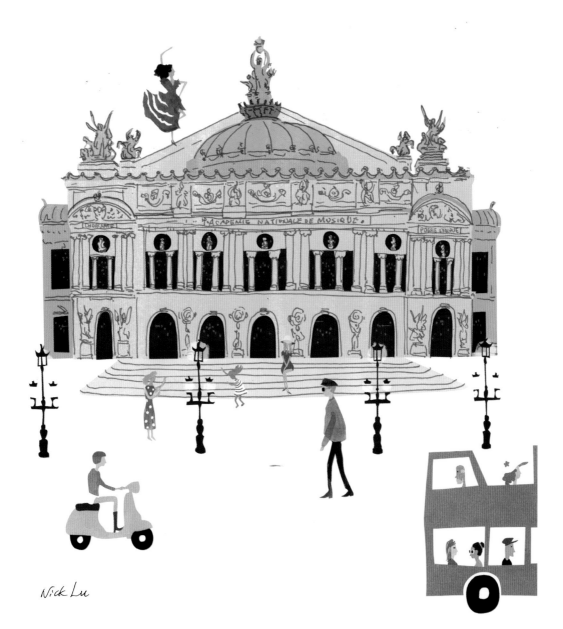

Nick Lu

48.8707, 2.3320

LIBRARIES

LA Public Library, 1926

A great library contains the diary of the human culture and its spirit.

34.0510, -118.2550

Bibliothèque F. Mitterrand
(Bibliothèque nationale de France), 1998

Colorado Street Bridge, 1913

34.1449, -118.1654

G*

Pont Neuf, 1603

Bridges become frames
for looking at the world
around us.
— BRUCE JACKSON

48.8580, 2.3420

G*

Venice Canals, 1905

Nick Lu

33.9842, -118.4660

Canal Saint-Martin, 1825

Waterways are charged with magic.

48.8780, 2.3660

BEACONS

Samitaur Tower, 2010

34.0269, -118.3807

Nick Lu

La Grand Arche de la Défense, 1989

Nature often holds up a mirror so we can see more clearly the ongoing processes of growth, renewal, and transformation in our lives. — MARY ANN BRUSSAT

Nick Lu

48.8930, 2.2360

Griffith Observatory, 1935

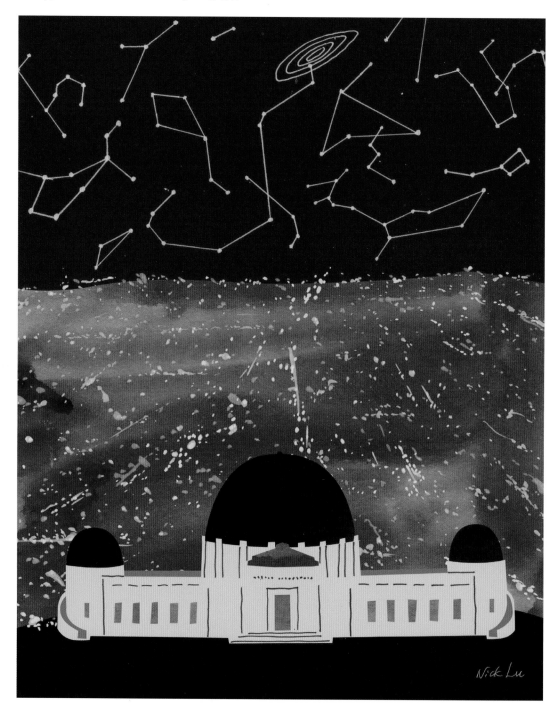

34.1181, -118.3003

Hôtel des Invalides, 1676

The stars above us, govern our conditions. —WILLIAM SHAKESPEARE IN *KING LEAR*

48.8630, 2.3140

2 Culture Cèlébre: Cinema, Entertainment, & Glamour

Dreams are extremely important. You can't do it unless you imagine it.
— GEORGE LUCAS

LA Much of the world's popular culture emanates from Los Angeles—it is thought by many to be one of the most creative cities in the world. One of every six people in LA works in a creative industry and is connected in some special way to the city's innovative, independent, and free lifestyle.

Los Angeles, sometimes referred to as La La Land or Tinseltown, is the embodiment of the entertainment business. During the early years of the twentieth century, the growth of the motion picture business began with the arrival of D. W. Griffith in 1909 and Cecil B. DeMille in 1913. This fueled development and created the future identity of the burgeoning city. Filmmakers were lured by the sunshine and mild climate, which made it possible to film year-round. The city's varied topography and architecture provided filmmakers with an infinite number of locations for an infinite variety of scripts—making LA the first great movie studio. Even today, when passing a film set on a street in LA, it is difficult to separate the present from history and fact from imagination or memory.

The Hollywood sign is a landmark and an internationally recognized symbol of the Golden Age of cinema. LA's film industry, employing thousands, accounts for the highest percentage of films produced around the world. Films, through their stories and movie stars, fuel the fantasies of millions, providing dreams of mobility, a better life, romantic love, travel, leisure, and adventures of all sorts. An integrated lifestyle has emerged in Los Angeles based

on the Hollywood myth, transforming LA into a "City of Dreams."

Hollywood itself is LA's most famous district. Its very name is synonymous with the entertainment business and dreams of glamour, money, and overnight success. It is a magnet for tourists, actors, and musicians filling their insatiable appetites for celebrity and fantasy. The Chinese Theatre transports you to Hollywood's golden age, and it is there that you can catch a glimpse of the hand and footprints of cinema's most famous actors and actresses. This spot marks the beginning of the Hollywood Walk of Fame, which was created to capture the essence of celebrity by awarding famous individuals a terrazzo and brass star-shaped plaque along the palm-lined sidewalk. The Dolby Theatre, located nearby at the famous corner of Hollywood and Highland, is now home to the Academy Awards (or Oscars). This show has captured the world's imagination since 1929. When awards season descends on LA, between November and March, the glamorous feeling of Hollywood becomes even more real. The electricity that moves through the city is palpable. But perhaps no place hides the secrets of Hollywood better than The Magic Castle, located in the shadows of the great theatres, where magic shows entertain adults in a members-only club housed in a Victorian mansion.

Nearby in Hollywood is the circular Capitol Records building, designed in 1956 to resemble a stack of records. It has a rooftop needle that flashes out Hollywood in Morse code and is one of the city's most iconic and famous landmarks. LA became the center of the recording and music industry in the 1970s, attracting musical talent from all over the world. Hollywood has what is often referred to as the greatest record store of all time, Amoeba Music, which houses thousands of CDs, tapes, DVDs, and vinyl records, including a wealth of classics. It is a collector's dream. Hollywood Forever Cemetery, built in 1899 but recently restored after years of neglect and impropriety, is now the home to weekly outdoor film screenings and pop, folk, and rock concerts, held over the gravestones of Jayne Mansfield, Johnny and Dee Dee Ramone, and Bugsy Siegel.

In its entirety, Sunset Boulevard is a snapshot of LA's unique, energetic, and independent lifestyle and culture. At its heart is the Sunset Strip, a mile-and-a-half stretch that winds along the southern slope of the Santa Monica Mountains and is famous for its glittering night life, glamorous (and gritty) clubs, hotels, restaurants, and shops. Famed venues such as the Viper Room, the Whisky a Go Go, the Roxy, and the House of Blues have made LA a rock 'n' roll music mecca. One of the strip's finest architectural gems, and a picturesque *rendezvous,* is the legendary Chateau Marmont hotel, built in 1927. The hotel exudes old Hollywood charm and has become a retreat for the rich and famous.

West of the Sunset Strip lives a very different type of individual. Sometimes called the most fabulous six square miles on earth, Beverly Hills is synonymous with fame, an opulent lifestyle, and extraordinary wealth. The image of a "rich person's playground" has been created and maintained by the media. The 90210 zip code attracts visitors and Angelenos who want to get a sense of the lifestyle. Among Beverly Hills' most famous draws are the lavish residences of movie legends and the rich and famous. The signature pink façade and striking bell towers of the Beverly Hills Hotel, sometimes called the Pink Palace, is a legendary and enduring landmark. Its grounds, bungalows, suites, pools, and restaurants are rich in Hollywood history and imbued with an aura of mystique and glamour. Adjacent Bel Air boasts its own beautiful Hotel Bel-Air, as well as gated communities of the well-to-do and well-known.

But Sunset Boulevard doesn't stop there. The bohemian cultures of Silver Lake, Los Feliz, and Echo Park are a fusion of creative people who fill the many coffee houses, yoga studios, organic eateries, and shops that line the streets. This is also the Los Angeles of architects Frank Lloyd Wright and Richard Neutra, whose legacies can be seen in the modernist homes that enrich the surrounding hills.

Over the glamorous Hollywood Hills lies the bustling and just as influential, but oft overlooked, San Fernando Valley (referred to as "The Valley"). Many movie studios, music labels, and television studios are located here in Burbank and Studio City. NBC Universal, CBS, and Warner Brothers offer tours and live audience tapings, providing a great way to see the working environment of a studio.

Disney is one of the most visible studios with its building shaped like Mickey's wizard hat in *The Sorcerer's Apprentice*, but it does not offer tours, preferring people to visit Disneyland, just under forty miles southwest of LA in Orange County. Its founder, Walt Disney, pioneered the concept of a theme park, and when Disneyland opened in 1955, it fundamentally changed the leisure industry by offering escapism to the masses.

A favorite Valley spot is Bob's Big Boy, a diner and drive—in restaurant known for its Googie style of architecture and double-decker burgers. The mainstay burger joint expanded in its heyday of the '60s, '70s, and '80s. In fact, David Lynch is known to have gone there just about every day from the mid-seventies until the early eighties to have a milkshake and sit and think. Today, the relic serves as a nod to the height of LA car culture, with weekly hot-rod shows.

Located throughout the San Fernando Valley are aerospace, electronic, and research companies, as well as the multi-billion dollar pornography industry. These industries

stimulated population growth and the development of endless subdivisions of homes, creating a homogeneous cityscape for its almost 1.8 million residents. The Valley is the epitome of suburban sprawl. Without a real center, the main thoroughfare is Ventura Boulevard, which is filled with ritzy cafés and chic suburban boutiques so those who live here can partake in the LA lifestyle.

In LA it is sometimes difficult to distinguish dreams from reality. LA exemplifies a larger-than-life image of glamour and magic. Many people who are drawn to this city have big dreams that they hope will become a reality—like the successes they fantasize about. They are lured by the promise of feeling liberated in a city that abounds with opportunities and encourages people, especially entrepreneurs, to take chances in order to make their dreams come true.

In the future, everyone will be world-famous for fifteen minutes. —ANDY WARHOL

Whatever you can do, or dream you can do, begin it.
—JOHANN WOLFGANG VON GOETHE

Paris

Paris is a delightful city, for it seems to know the human soul. It knows its need for beauty and greatness, space and intricacies, perspectives and projections—layers of accumulated greatness. People there have been working for over two thousand years at how to have a good time and how to enjoy life, conjuring images of "old fun and new fun."

Cinema was born in Paris in December 1895 when the first film was shown in the basement (*cave*) of the Grand Café on the Boulevard des Capucines, made possible by Auguste and Louis Lumière's invention of the cinématographe. French movies, most often originating in Paris, compose a rich and unbroken tradition of glamour and artistry and have captured César Awards, as well as many Oscars, over the years.

The famous line from the movie *Casablanca*, "We'll always have Paris," communicates just how iconic the city became as a perfect backdrop for movies—offering a limitless supply of perspectives and moods. The cityscape with the sun setting over the Seine, the swirl of traffic around the Place de la Concorde, the working class neighborhoods, and the storied cafés have been infinitely photographed and can be recognized by moviegoers everywhere. Love, sophistication, eroticism, danger, class struggle, violence, tenderness, political intrigue—any effect, theme, or motif is likely to have a Paris address. And when I am in Paris, I have the inescapable sensation that I am a primary character cast in the tapestry of yet another meaningful Parisian film.

The French film industry has remained particularly strong due in part to protections afforded by the French government. And for many decades, Paris has served Hollywood well, providing it with some of its greatest love stories, mysteries, action films, and thrillers.

Parisians love their movies. Paris has the highest number of cinemas in any one city in the world, and it ranks as one of the largest film markets globally, by far the most successful in Europe. Le Grand Rex, an Art Deco masterpiece that opened in 1932 and hosts many star-studded premieres, is its largest movie theatre as well as a historic monument.

L'Olympia is a famous music hall on the Boulevard des Capucines that has showcased a variety of legendary French performers, many of whom have received great international acclaim, such as Édith Piaf. It has also showcased a number of contemporary stars, including Madonna, Led Zeppelin, the Beatles, Leonard Cohen, and Lady Gaga, to name a few. Of course, the art of cabaret, which originated here, is perfected at the legendary Moulin Rouge. Founded in 1889, it is so influential that its Can-Can dancers appear in the well-known posters by Henri de Toulouse-Lautrec. The windmill is its visual trademark, standing prominently above Pigalle, an area filled with night clubs and live music venues. The mystique of magic can be experienced in Paris at Le Double Fond café-théâtre de la magie in the Marais, a favorite place for Parisians to go. The Place du Tertre in Montmartre, where artists paint in a picturesque square lined with cafés and shops, is the epitome of Paris' unique and enduring charm. It is impossible not to feel the energy and excitement here.

La Place des Vosges, a square in the Marais, was built at the beginning of the seventeenth century and combines the greatness and modesty that is Paris. Its trees form a continuous screen of interlaced branches in front of the arcaded buildings filled with charming art galleries and restaurants—a perfect place to sit, read, think, draw, or people watch.

Interestingly enough, the world's most visited cemetery, the Cimetiere du Père Lachaise, opened in 1804 and is the city's most fashionable final address. Tombs of famous composers, writers, actors, painters, and musicians are buried here in a forty-eight-hectare (about 120-acre) sculpture garden. The most visited gravesites by both Parisians and tourists are those of author Oscar Wilde and 1960s rock star Jim Morrison.

The broad, beautiful, and bustling tree-lined Champs-Élysées, with the landmark Arc de Triomphe at one end and the Place de la Concorde at the other, is the most famous thoroughfare in Paris, and possibly in the world. The avenue has symbolized the style and *joie de vivre* of Paris for centuries. Often described as being very commercial and even kitsch, the Champs-Élysées draws people in droves. The Champs, as the locals refer to it, is replete with large luxury shops, prominent theatres, clubs, bars, cafés, and exquisite hotels and restaurants. Automakers like Renault, Peugeot, and Citroën showcase their latest models in state-of-the-art showrooms in a museum-like setting. But perhaps most importantly, the

Champs-Élysées serves as a platform for Parisians to celebrate. Whether a sports victory, the country's annual Bastille Day (Independence Day), or even a political win, the Champs is where the city gathers and the strongest sense of community is felt.

And then there is Disneyland Paris—the first of Disney's theme parks to land outside of America. Perhaps surprisingly, it is the most visited attraction in all of France. The theme park opened in 1992 and is located twenty miles east of the center of Paris. It takes about thirty minutes to get there by train from Paris, making it easily enjoyable for both Parisians and visitors to play and be young at heart.

There are two ways of spreading light: to be the candle or the mirror that reflects it. — EDITH WHARTON

Paris is both.

BLONDES

Marilyn Monroe, 1926

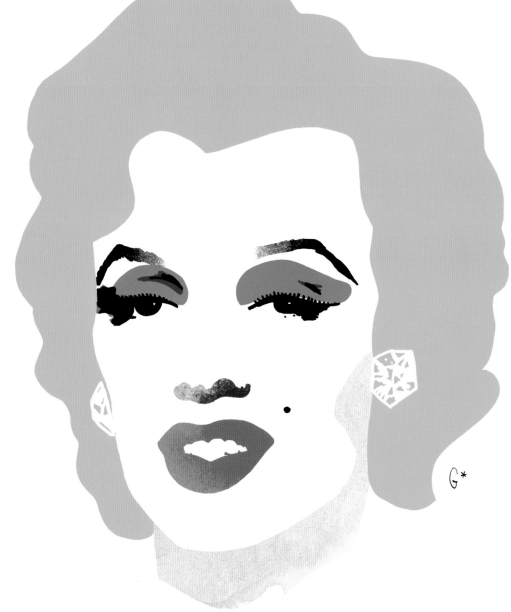

A girl should be two things:
[sexy] and fabulous. —COCO CHANEL

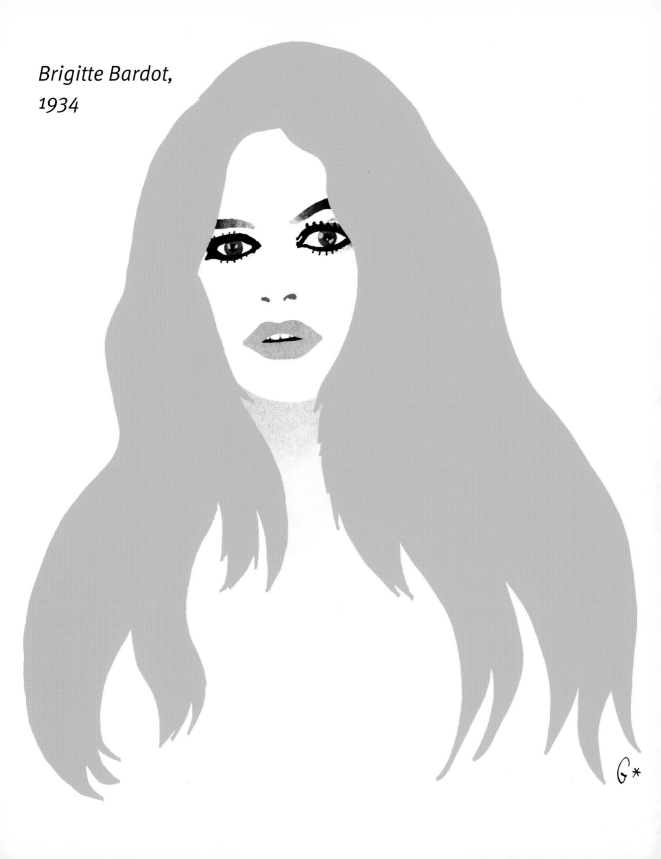

Brigitte Bardot,
1934

GC, 1961

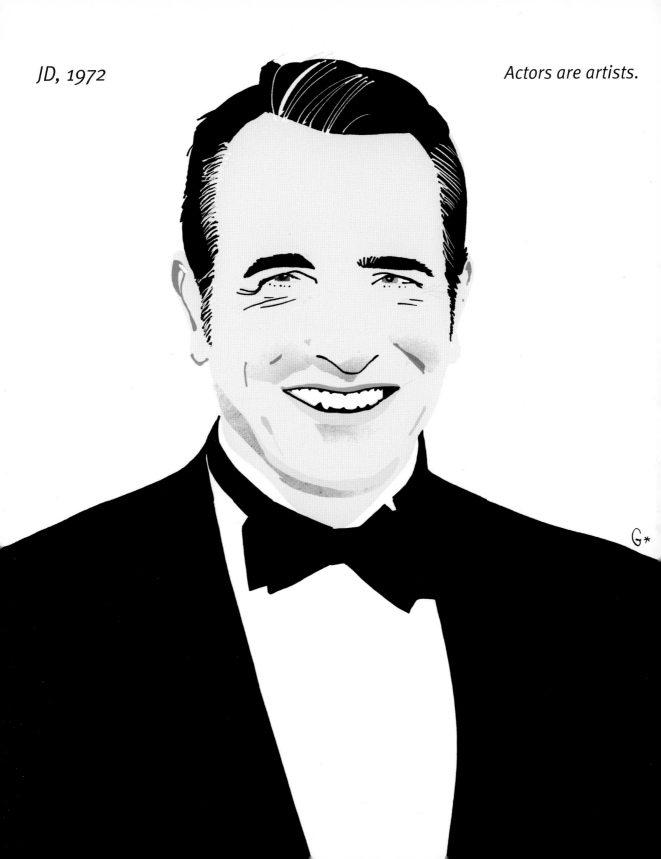

JD, 1972

Actors are artists.

G*

Oscar, 1929

Nick Lu

César, 1976

*I love acting. It is so
much more real than life.*
—OSCAR WILDE

Nick Lu

Chinese Theatre, 1927

Marilyn Monroe

Sophia Loren

George Clooney

Nick L

34.1017, -118.3410

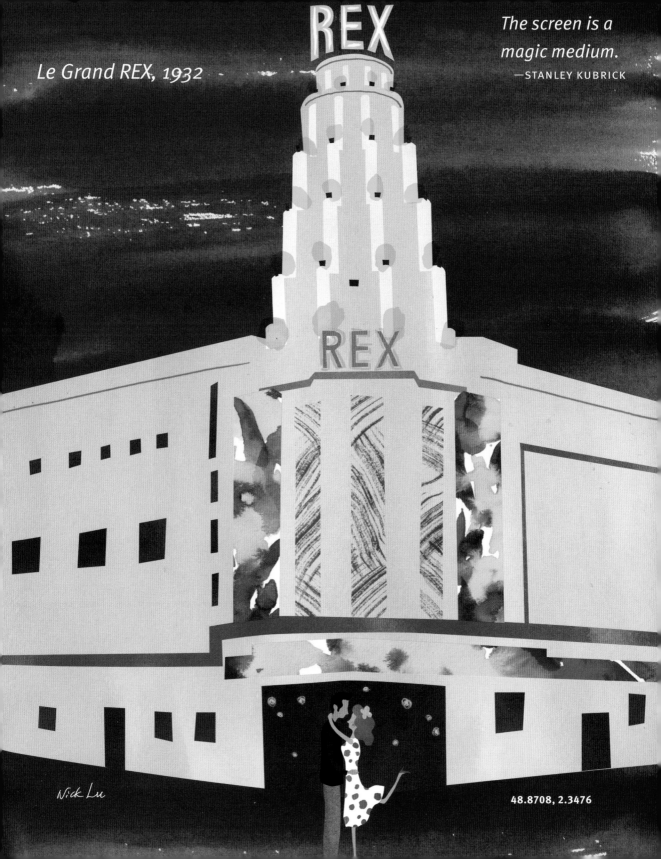

REX

Le Grand REX, 1932

The screen is a magic medium.
—STANLEY KUBRICK

REX

Nick Lu

48.8708, 2.3476

Hollywood Walk of Fame, 1958

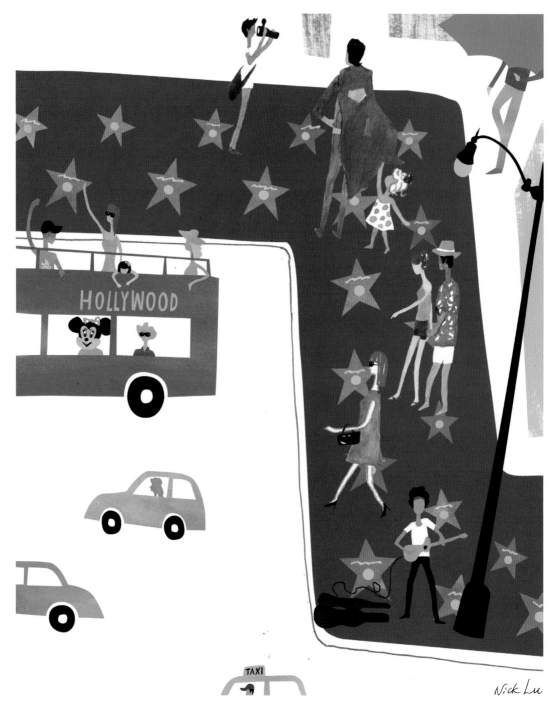

34.1013, -118.3421

Place du Tertre

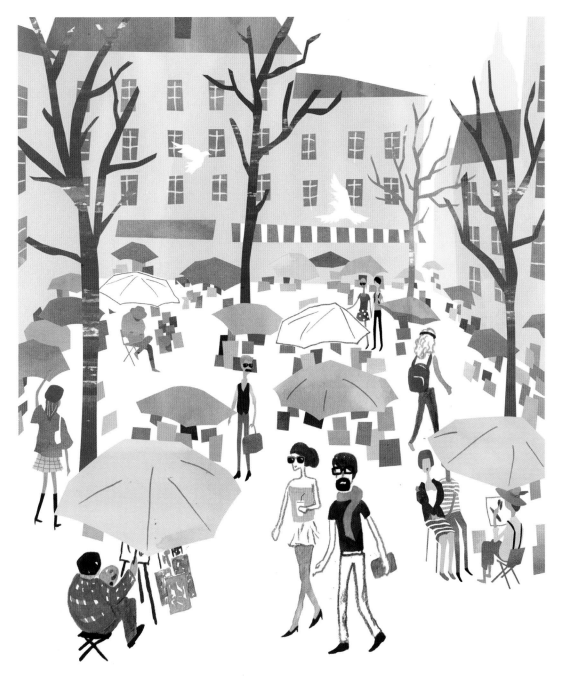

Nick Lu

48.8867, 2.3410

CURRENCY

Dollars

Nick Lu

Euros

Nick Lu

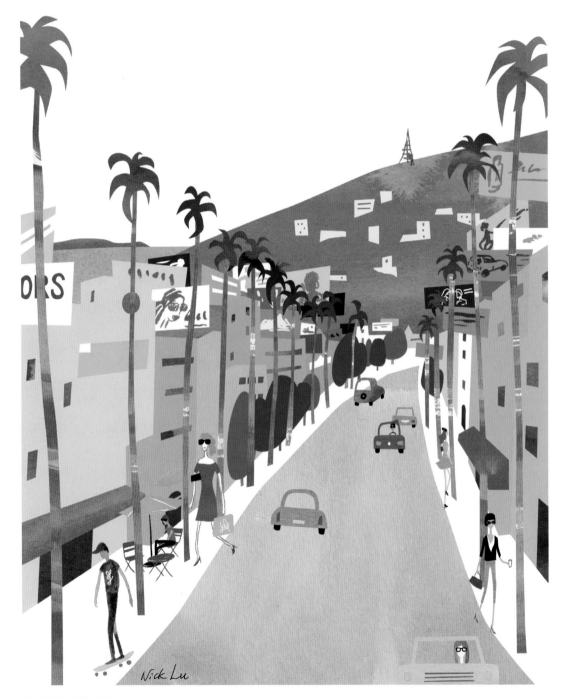

34.0923, -118.3800

Champs-Élysées

You need to walk a city's streets to see its soul.

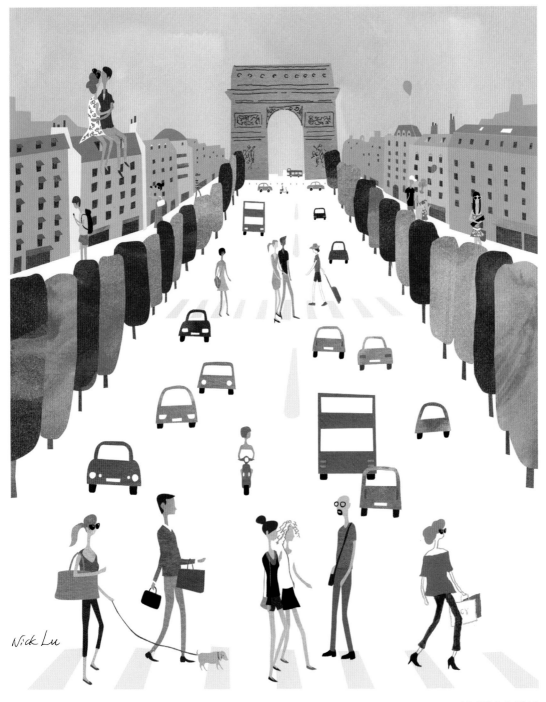

Nick Lu

48.8710, 2.3040

RESPITES

Chateau Marmont, 1929

Chateau
Marmont

*Architects of grandeur often
have visions of greatness.*

34.0982, -118.3685

Nick Liu

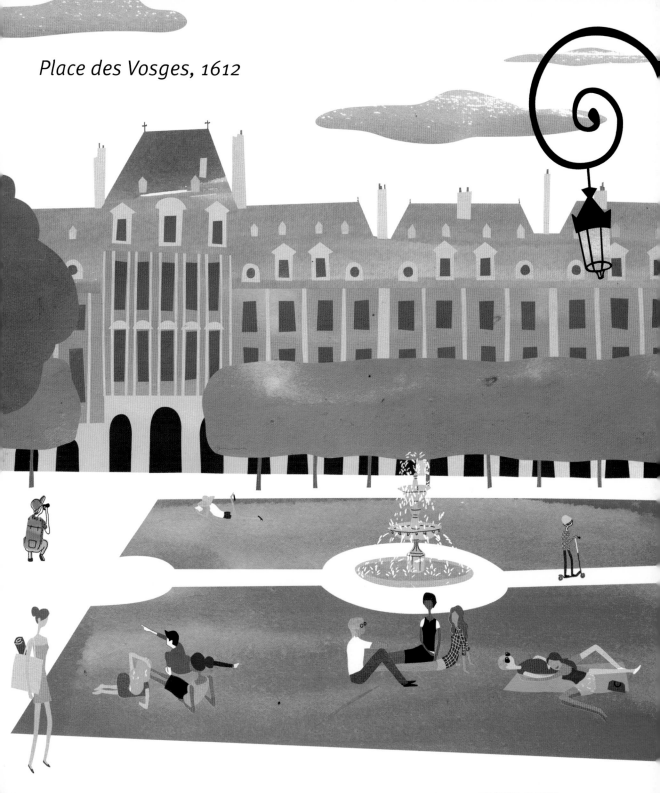

Place des Vosges, 1612

48.8560, 2.3650

Nick Lu

Beverly Hills Hotel, 1912

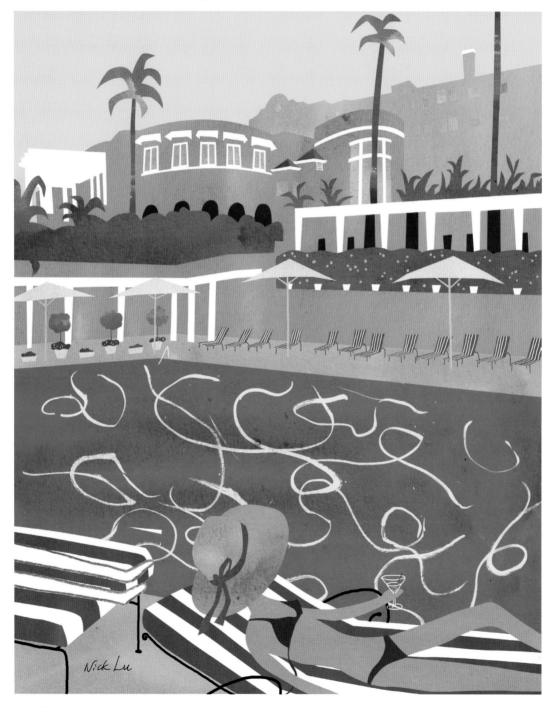

34.0815, -118.4127

I think there is something about luxury—it's not something people need, but it's what they want. —MARC JACOBS

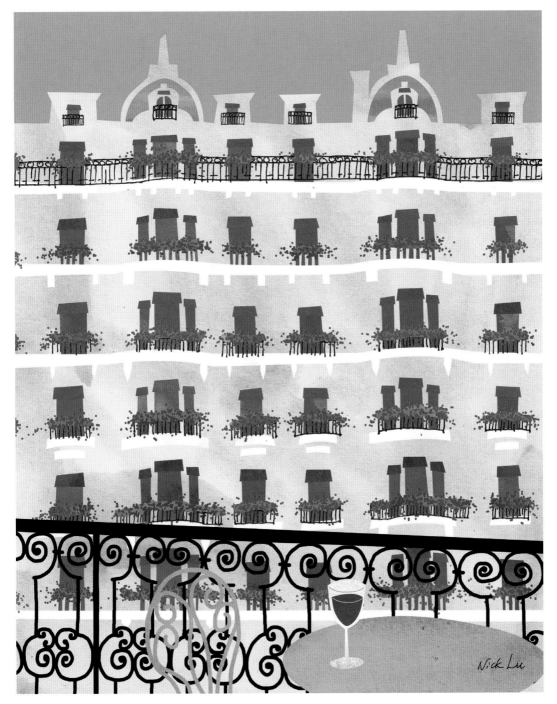

Nick Lu

48.8660, 2.3040

BARS

SkyBar

An intelligent man is sometimes forced to be drunk to spend time with his fools. —ERNEST HEMINGWAY

34.0945, -118.3745

Moulin Rouge, 1889

If you obey all the rules,
you miss all the fun.
—KATHARINE HEPBURN

MOULIN ROUGE

Nick Lu

48.8841, 2.3324

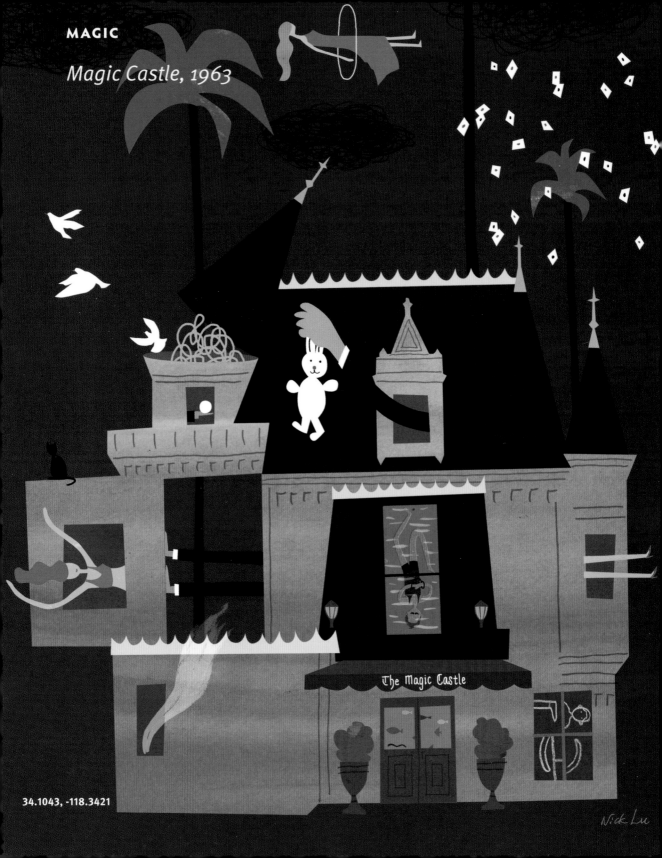

Le Double Fond café-théâtre de la magie, 1988

*The real secret of magic
lies in the performance.*
—DAVID COPPERFIELD

E DOUBLE FOND LE CAFÉ - THÉÂTRE DE LA MAGIE

48.8532, 2.3612

Nick Lu

Disneyland, 1955

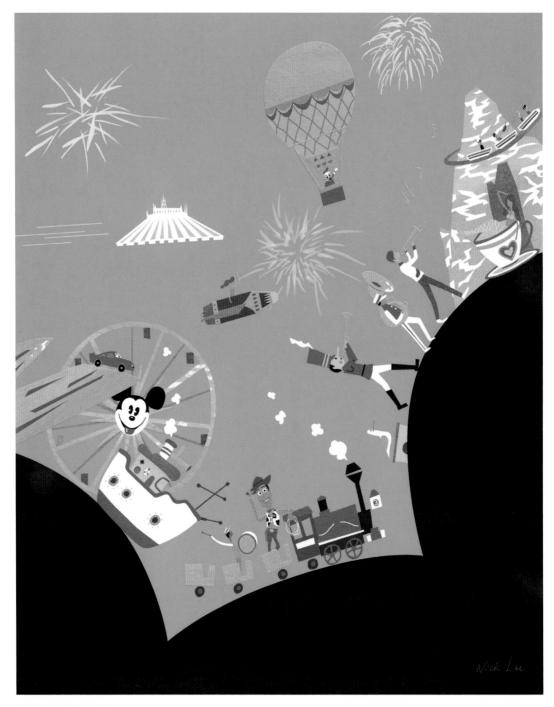

33.8110, -117.9244

Disneyland Paris, 1992

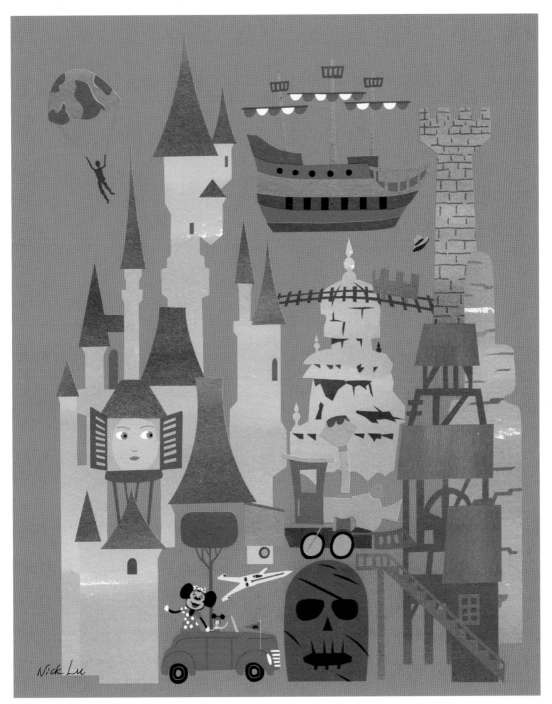

It was all started by a mouse.
—WALT DISNEY

48.8710, 2.7770

Hollywood Bowl, 1922

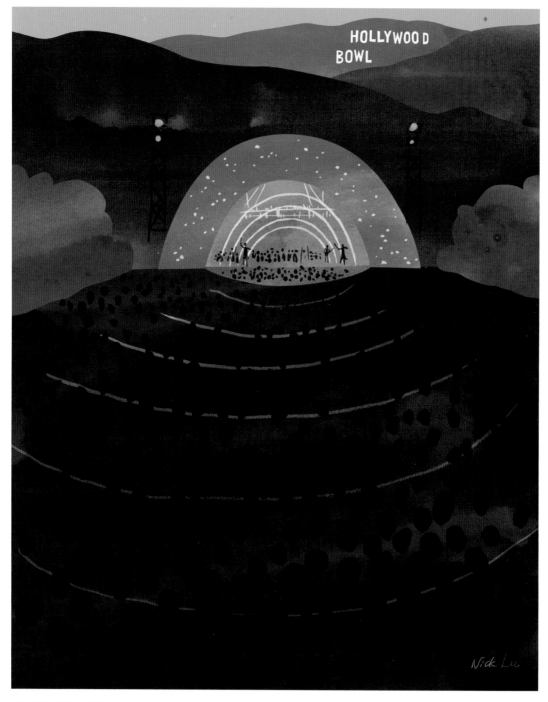

34.1120, -118.3384

L'Olympia, 1889

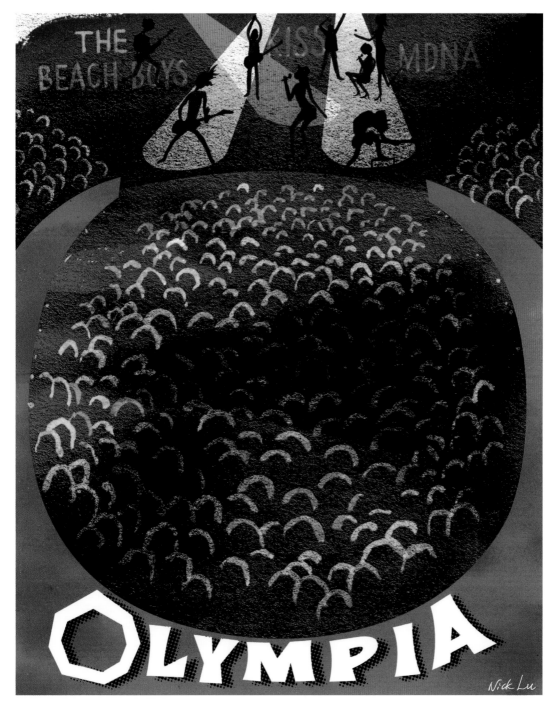

48.8701, 2.3283

CIRCULAR BUILDINGS

Capitol Records, 1956

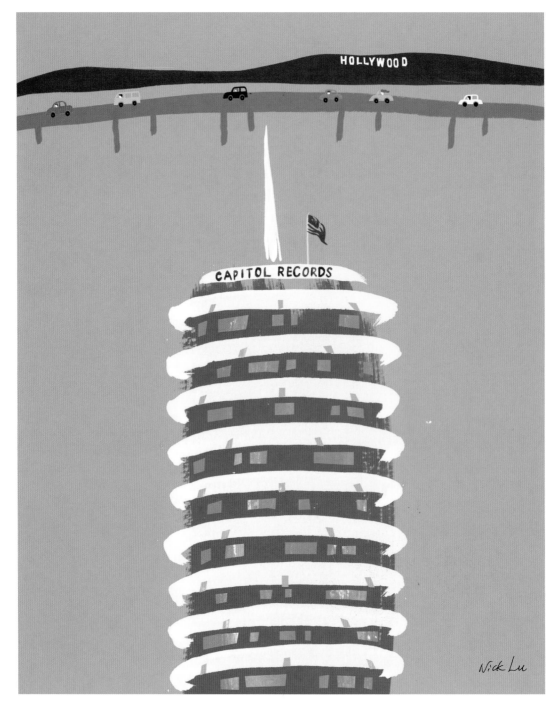

Radio France, 1963

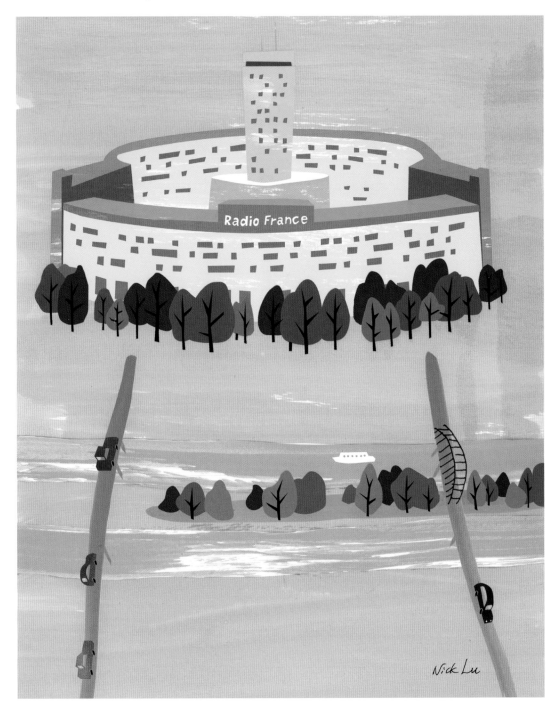

Nick Lu

48.8520, 2.2790

Amoeba Music, 2001

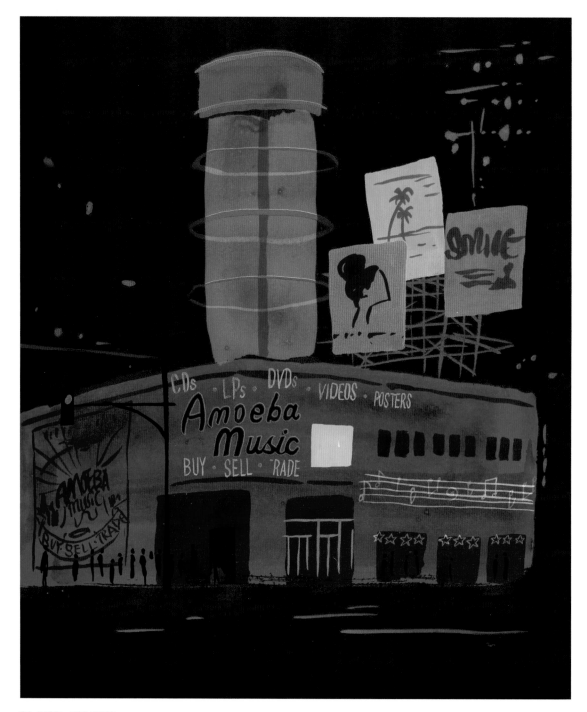

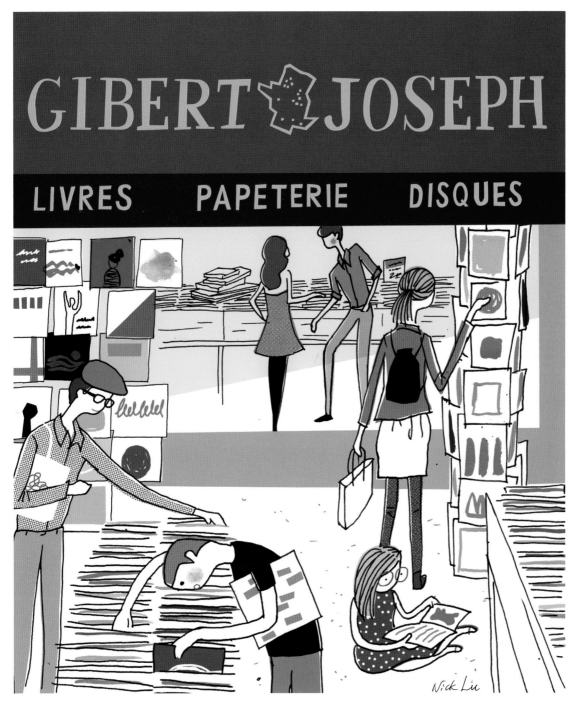

Michael Jackson, 1958–2009 (Forest Lawn Cemetery)

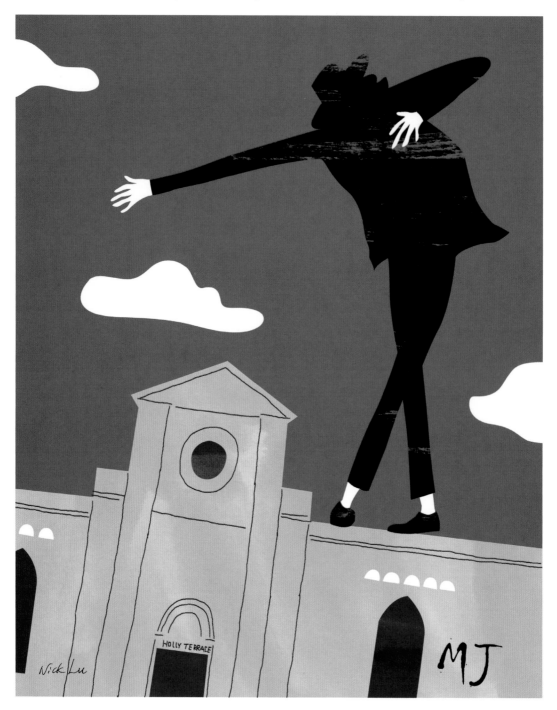

34.1476, -118.3288

Jim Morrison, 1943–1971
(Père Lachaise Cemetery)

There are things known and things
unknown and in between are the doors.
—JIM MORRISON

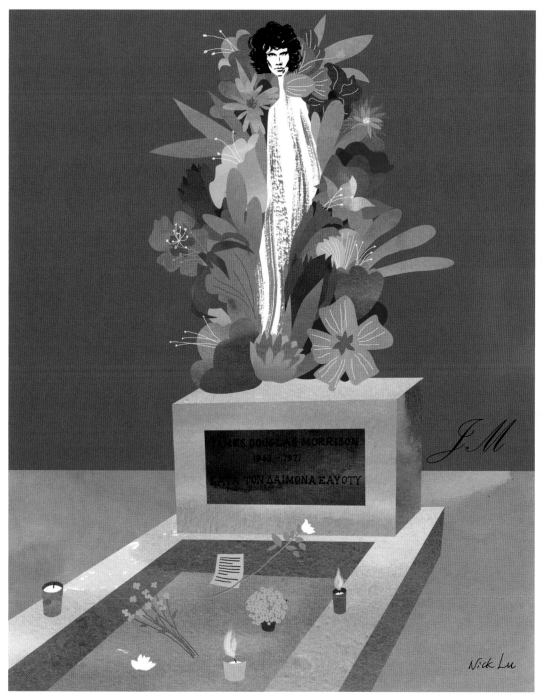

3 Fashion, Style & Shopping à la Mode

Fashion changes—style remains. —COCO CHANEL

LA Even when challenged by other major fashion cities such as Paris, Milan, Tokyo, or cross-country rival New York, Los Angeles holds its own. The LA state of mind has made a global impact. The city's laid-back culture has spawned a surge of casual and sportswear designers over the past six decades and, even more recently, a home base for haute couture designers, Hollywood stylists, and world-renowned contemporary brands. There is an undeniable tapestry of inspiration, talent, and trends that has permeated all aspects of style.

At the heart of LA's style essence is the relaxed and nonchalant look of a T-shirt and jeans, which, according to Yves Saint Laurent, is spectacular, practical, modest, sexy, and simple. Even New Yorkers can agree that LA is the world's denim capital, but it is so much more than that. LA-based denim brands have elevated and redefined the classic pair of jeans to a level of premium design. The city is home to the world's most renowned wash houses, where acid, enzymes, holes, rips, and bleach are added to the jeans. Denim fabrics from other countries, like Japan and Italy, are often shipped to LA for distressing and mass manufacturing.

But it's not just denim: fashion trends in LA are a collage of Hollywood-influenced glamour, Topanga Canyon romantic bohemian, Manhattan Beach surfer, Sunset Strip rock star, Melrose vintage, Eastside hipster, Valley eclectic, and suburban preppiness. The city is home base for such noteworthy designers as Trina Turk, Paula Thomas of Thomas Wylde, Rick

Owens, Scott Sternberg of Band of Outsiders, Kate and Laura Mulleavy of Rodarte, Andrea Lieberman of ALC, Jenni Kayne, James Perse, Cynthia Vincent, Monique Lhuillier, Hedi Slimane, and Jerome C. Rousseau. Many well-known commercial brands, including Guess, Juicy Couture, American Apparel, and BCBG, have found worldwide notoriety.

Naturally, LA style tends to be free and playful, but there is also an undeniable aesthetic of youth. Along with any great wardrobe comes a great dermatologist, cosmetologist, and, often, plastic surgeon. "They are beautiful," Andy Warhol once commented. "Everybody's plastic, but I love plastic. I want to be plastic." But it's not just your Beverly Hills housewife; the adult entertainment industry commands its own set of standards, often ostentatiously in both body and fashion. Though she never dabbled in porn directly, Angelyne could perhaps be considered one of LA's most famous faces of augmentation and gaudy fashion choices.

But perhaps there is no influence felt stronger worldwide than that of Hollywood. Old-Hollywood glamour is a recurring theme in fashion for high-end designers, and every red carpet serves as a walking advertisement for them. Annual awards shows such as the Academy Awards, Grammys, and Golden Globes impact style trends perhaps more profoundly than any runway show. As long as the world's appetite for celebrity and fantasy remains insatiable, this town's fashion will remain a force.

Shopping is a serious priority for Angelenos. Perhaps best known is legendary Beverly Hills, notorious for its ritz and glitz. Rodeo Drive is one of the world's most famous and expensive shopping streets, and is synonymous with a lifestyle of luxury and fame. European and American designer brands, including those from Los Angeles, have created luxurious and architecturally spectacular flagship stores here. Visitors and locals alike crowd the sidewalks of the Golden triangle (the area bounded by Wilshire Boulevard, Canon Drive, and Santa Monica Boulevard) to be awed by the opulence and decadence of the shopping, dining, and luxurious hotels, and maybe a celeb sighting or two.

Next door, West Hollywood boasts multiple streets of unmatched boutiques. On Melrose West, Maxfield was the first high-end boutique to bring European and Japanese designers to the city, long before Barneys New York opened its doors. Down the road, Robertson Boulevard became a mecca for socialites and paparazzi with the opening of Kitson, but Ralph Lauren, Chanel, Tommy Hilfiger, and many more have also opened small shops along the high-profile street. Down the way, quiet, tree-lined Melrose Place, off equally chic Melrose Avenue, showcases LA shopping at its best, as old homes and apartments have been converted into comfortable, furniture-heavy boutiques.

Fred Segal, known for its ivy-covered edifice, has enjoyed decades as one of the city's biggest trendsetters. Melrose East (that is, the area just east of Fairfax Avenue) is the purveyor of LA's punk and vintage culture, filled with small, independently owned student-friendly and trend-driven shops. Down Fairfax, one will find an outpouring of the best of LA's skate culture that serves as a mecca for sneakerheads, while the nearby Grove shopping mall, complete with animated fountains, a trolley, regular outdoor concerts, and the adjacent Farmers' Market, is family and first-date friendly. More boutiques line the edges of West Hollywood on Beverly Boulevard and Third Street, where one can easily stumble on a sidewalk café, cupcakery, or apothecary whilst sorting through eclectic vintage finds and curated comfort.

Further west, the beach cities have found their own vibe: boutiques along Abbot Kinney Boulevard in Venice Beach have opened in former houses and lofts. The street stretches into Santa Monica's more family-friendly Main Street and further into the modernized Third Street Promenade, adjacent to the Santa Monica Pier. Up the Pacific Coast Highway, locals loosen up at the Malibu Country Mart, and some find their way into the hippy and artist enclaves in Topanga Canyon.

Downtown Los Angeles, however, has experienced a seismic explosion of shopping and fashion. Choosing cheaper rent and proximity to the city's best art galleries, both local and international designers are converting turn-of-the-century and Art Deco spaces into their own works of art. High-end boutiques and specialty stores are filling the once run-down storefronts with unique finds, but Santee Alley is locally famous for factory-direct prices and designer knockoffs.

Smaller neighborhoods like Silver Lake and Los Feliz boast their own unequaled outlets and a bevy of second-hand and vintage boutiques, but treasure hunters and vintage aficionados from all over the world make Pasadena's Rose Bowl Flea Market a must-see.

Undoubtedly, and despite its youth, LA is a cultural crossroads and international marketplace defined by great service (just ask for a coffee or glass of champagne and nearly any retailer will happily comply), bountiful options (anything can be found!), cutting edge design, and, of course, valet parking.

I always find beauty in things that are odd and imperfect— they are much more interesting. —MARC JACOBS

Fashion isn't a necessity. It pulls at your heart. It's a whim. You don't need it. You want it. —MARC JACOBS

Paris

Paris has been the international capital of fashion and style for over 300 years, dating back to the reign of Louis XIV. Haute Couture, a title reserved specifically for design houses that meet certain demanding criteria, originated in Paris in the 1860s, as did fashion shows and an emerging fashion press. Clothing was becoming big business, yet revered as an art.

Today, fashion is *very* big business in Paris. Its imaginative and innovative designers influence the direction of trends worldwide. The renowned fashion empires of Chanel, Dior, Givenchy, Louis Vuitton, Hermès, (Yves) Saint Laurent, and Lanvin, which are lined up around Rue Saint-Honoré, the Champs-Élysées, and Saint-Germain-des-Prés, are impressive and irresistible. So are the more artisanal designers with backroom *ateliers*, like Isabel Marant or Azzedine Alaia, found in pockets in the Marais, Bastille, and Montmartre.

Parisian fashion shows make the front pages and are the center of attention in the media. Excitement is felt at all events in the city that center around the semi-annual Fashion Week and its spectacular runway shows. The series of events are scheduled in September for Spring/Summer collections and in February for Autumn/Winter for buyers, press, and industry insiders. The series of shows are held in the Carrousel du Louvre as well as in other venues throughout the city. French designers hold nothing back when it comes to putting on a memorable spectacle of a fashion show. Treated as a seasonal art installation, the images of models hitting the runway in their new looks linger in the minds of both celebrities in the front row and fashion-lovers worldwide.

In Paris, fashion statements are always simple but pronounced. Parisians create their own signature style by mixing—colors with black and white, high end with low end, new with

vintage, masculine with feminine, intelligent chic with sexy. The styles in Paris can be described as *excentrique*, *romantique*, *classique*, sporty, *sophistiqué*, arty, and sexy. Parisians love to wear black—the little black dress is a staple in every Parisian woman's closet. In the words of Karl Lagerfeld, "one is never over-dressed or underdressed with a Little Black Dress."

Shopping in Paris is the ultimate retail therapy and is a near-spiritual experience. The quality and variety of products is extraordinary. The expertise and craftsmanship that is behind so many products is apparent everywhere in Paris. The concept store was invented in Paris and can still be seen today in the many unique boutiques, such as Colette and Merci, which attract browsing, buying, and hanging out. The grand *magasins* of Galeries Lafayette (1894), le Printemps (1864), and Le Bon Marché (1852) are, as Andy Warhol expressed, "kind of like museums—removing the difference between the fine arts and commercial arts." And if shoes are a passion, Christian Louboutin's shops create an equally beautiful and atmospheric *galerie*. Shop windows, with an emphasis on composition, design, and color, are an art form unto themselves. The displays are thoughtful, quirky, intended to delight, and always chic.

Virtually every global fashion house has a presence in the areas around Rue Saint-Honoré and Avenue Montaigne, but many more shopping districts exist within the city as well. Often, the same group of trendy stores set up shop in each of these areas, rotating as different contemporary *prêt-à-porter* (ready-to-wear) brands go in and out of vogue. That said, there is a specialized boutique for nearly everything here. Catering to both students and the affluent alike, the 6th arrondissement features some of my favorites. Near Saint-Sulpice lies Diptyque, a candle store known for its delightful fragrances and packaging. Annick Goutal's perfumes are also not to be missed, and jewelry store Les Néréides makes some of the most whimsical and beautiful costume jewelry in the world. Another popular jewelry store, Agatha, has silver pieces that make for fun, trendy statements, and I adore Charabia's couture for kids. Agnès b. makes clothing for men, women, and children that is classic and simple with a decidedly Parisian look. The wood-paneled Façonnable is also an easy favorite for preppy and colorful men's and women's wear. In and out of the art galleries of the Marais, shops like Isabel Marant, Surface to Air, and Spree have cutting-edge styles. Barbara Bui and Paule Ka mix masculine suits with feminine cuts and fabrics. But perhaps the best, once a boutique and now a goliath, is Sephora, where nearly every brand of makeup is housed. The most famous flea market in Paris, the Marché aux Puces de Saint-Ouen, lies in the outskirts of the city; it is a treasure trove for seekers of vintage items.

As with everything in Paris, there is always more to be discovered.

Fashion is in the sky, in the street, fashion has to do with ideas, the way we live, what is happening.

— COCO CHANEL

Paris

Everything in your closet should have an expiration date.
—ANDY WARHOL

Los Angeles

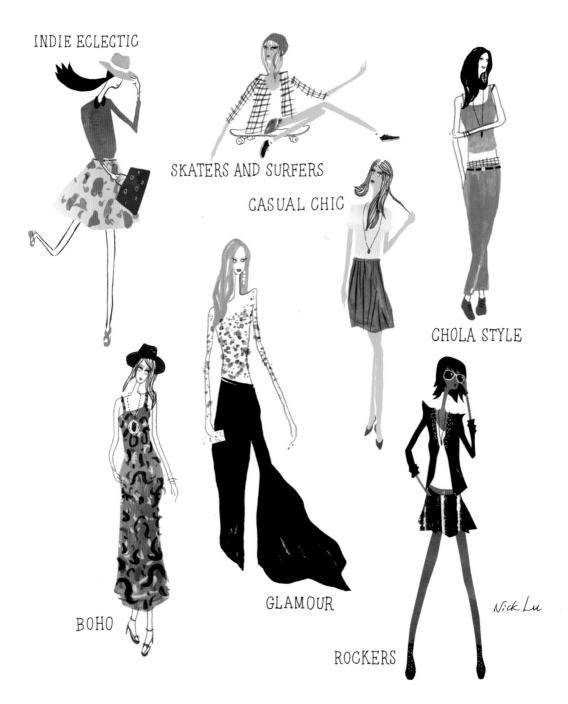

INDIE ECLECTIC

SKATERS AND SURFERS

CASUAL CHIC

CHOLA STYLE

BOHO

GLAMOUR

ROCKERS

Nick Lu

Fashions fade, style is eternal.
—YVES SAINT LAURENT

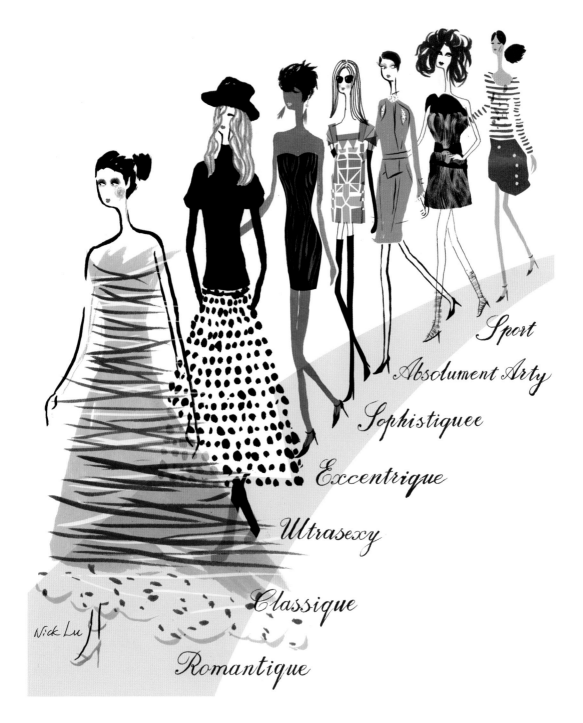

Sport

Absolument Arty

Sophistiquee

Excentrique

Ultrasexy

Classique

Romantique

Nick Lu

Los Angeles

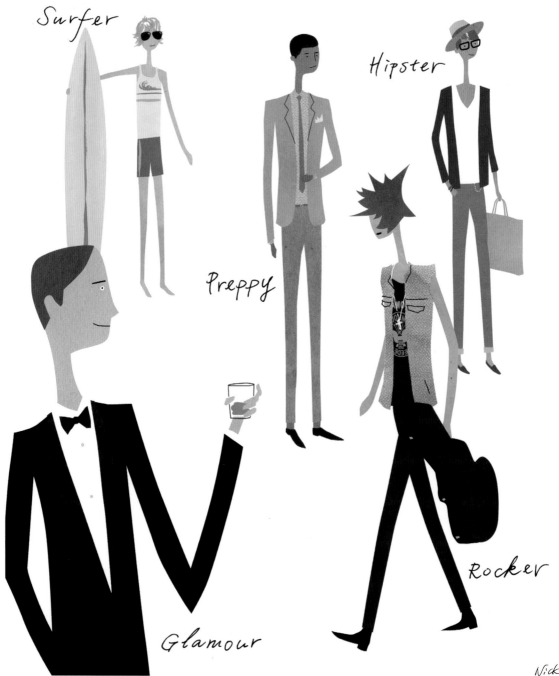

Surfer

Hipster

Preppy

Glamour

Rocker

Nick Lu

Paris

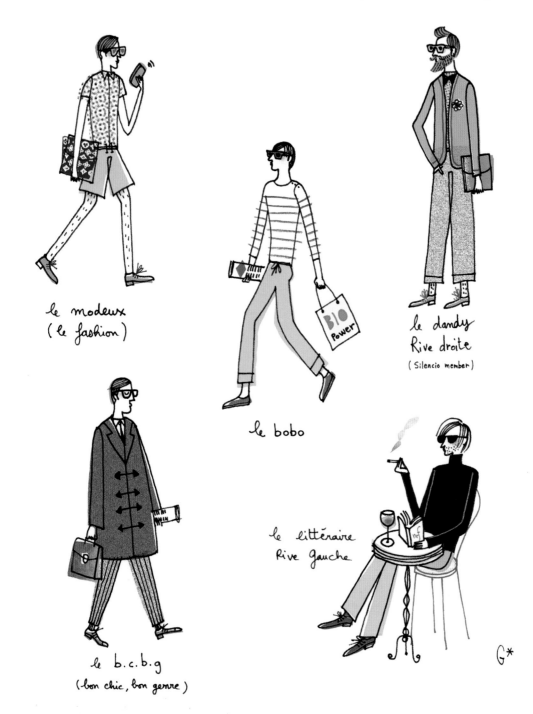

le modeux
(le fashion)

le bobo

le dandy
Rive droite
(Silencio member)

le b.c.b.g
(bon chic, bon genre)

le littéraire
Rive gauche

G*

MEN'S SHOES

Shoes

$G*$

Chaussures

*A shoe has so much more to offer
than just to walk.*
—CHRISTIAN LOUBOUTIN

Talons Hauts

Give a girl the right shoes and she can conquer the world. —MARILYN MONROE

G*

Sunglasses

Lunettes de Soleil

True originality consists not in a new manner but in a new vision.
—EDITH WHARTON

Nick Lu

DREAM

Life

Nick Lu

Tatouage

ick Lu

Paris Je l'aime

The Grove, 2002

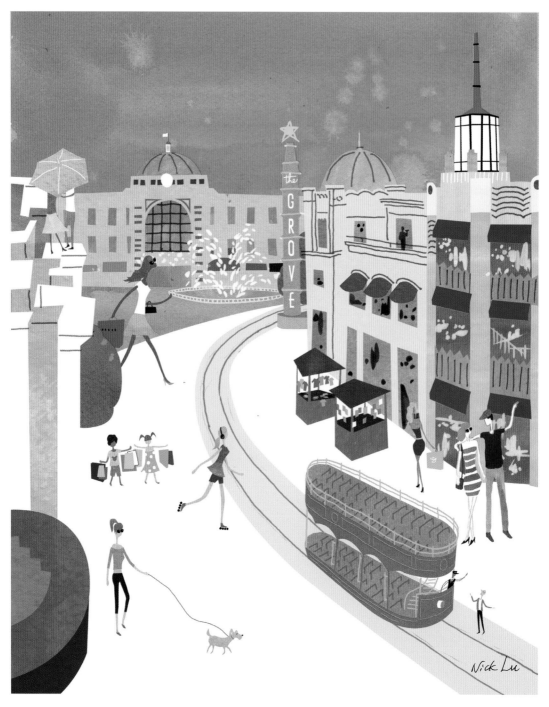

34.0722, -118.3579

Galeries Lafayette, 1895 *Shopping is the best retail therapy.*

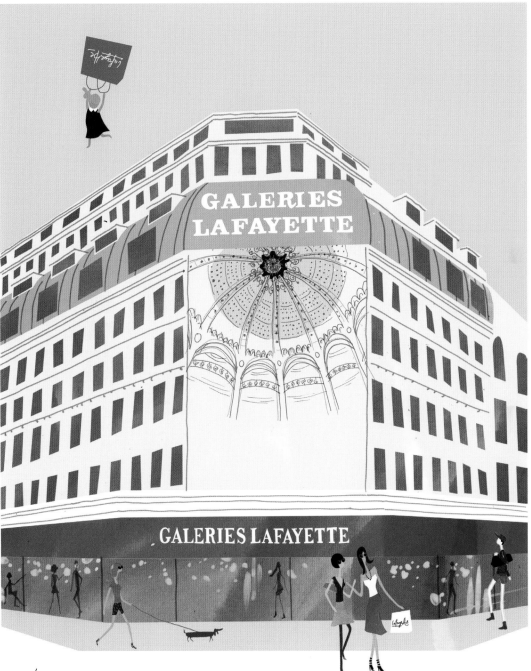

Nick Lu

48.8733, 2.3317

Rose Bowl Flea Market

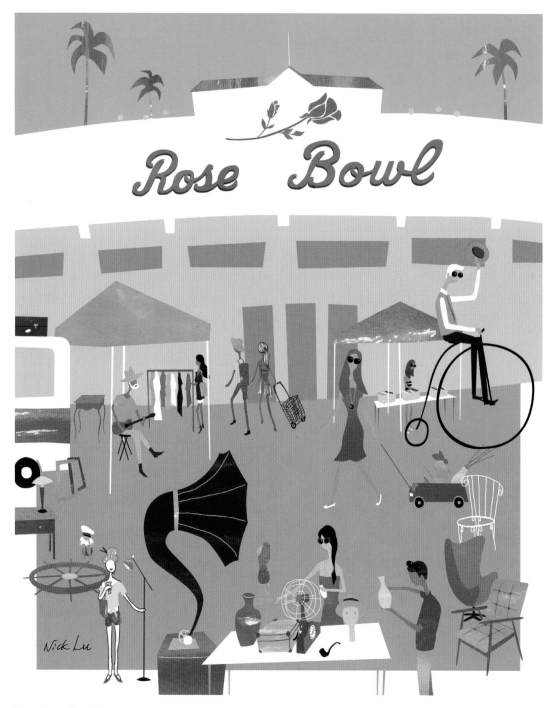

34.1611, -118.1675

Marché aux Puces

What is now called vintage was once brand new. —TONY VISCONTI

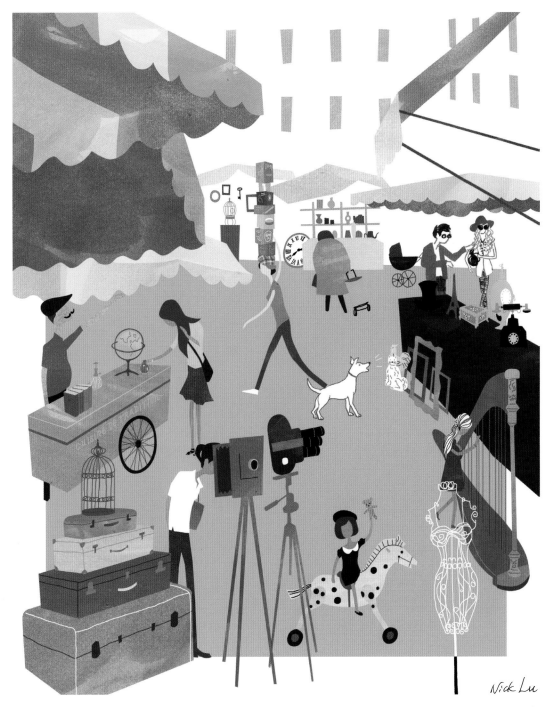

Nick Lu

48.8975, 2.3365

LUXURY SHOPPING

Rodeo Drive

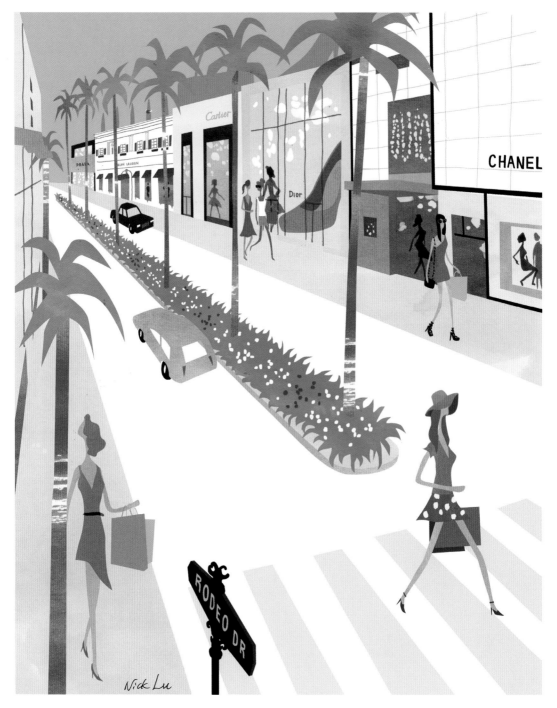

34.0671, -118.4009

Rue Saint-Honoré

We are shaped and fashioned by what we love. —JOHANN WOLFGANG VON GOETHE

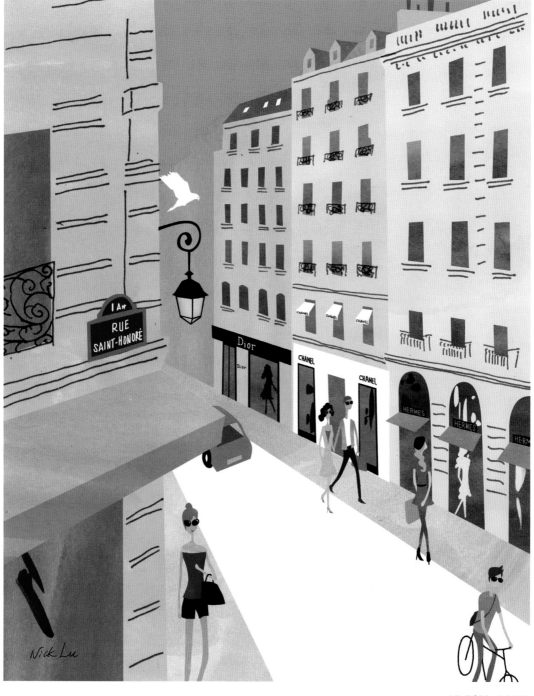

48.8684, 2.3232

BOUTIQUES

Fred Segal

Fred Segal

Fred Segal

Nick Lu

Colette

*One should always be
a little improbable.*
—OSCAR WILDE

Nick Lu

4 Sports & Leisure

Life is not anything, but an opportunity for something.
—JOHANN WOLFGANG VON GOETHE

LA Los Angeles was chosen to host the 1932 Olympic games, and was the first American city to do so since the games were revived in Athens in 1896. There were 1,332 athletes from thirty-seven countries, competing in 117 events across fourteen sports. The event stimulated development in the city, with the construction of the historic Biltmore Hotel downtown, the Los Angeles Memorial Coliseum (known then as Olympic Stadium), and the renovation of the Rose Bowl (1922) in Pasadena. While the Tenth Olympiad allowed Los Angeles to present itself to the world as a city that had arrived at major urban status, the Twenty-Third Olympiad in 1984 showcased a city that had become a cultural crossroads. This time, 6,829 athletes from 140 countries competed in 221 events across twenty-three sports. By using existing facilities and properly planning for venues and traffic, the 1984 Olympics were financially successful and a triumph for the city. The blending of sports and entertainment culture, in the form of Olympic events and television rights, created a model for future Olympic revenue streams.

Los Angeles is a town where sporting passions run high. The Staples Center opened in 1999 as part of a sports and entertainment complex known as LA Live. The Center is home to the Los Angeles Lakers and the Los Angeles Clippers of the National Basketball Association (NBA) and the Los Angeles Kings of the National Hockey League (NHL). The Los Angeles Dodgers Major League Baseball (MLB) team came to LA from Brooklyn in 1958 and currently play at

Dodger Stadium, built in 1962. It's a rite of passage for Angelenos to root for their home team and eat the team's famous Dodger Dogs.

Without a professional American football team since 1994, Angelenos focus more on university football. The cross-town rivalry between the UCLA Bruins, who play at the Rose Bowl, and the USC Trojans, who play at the LA Coliseum, is intense, and passions run high among their fans and supporters. There is also an enthusiastic following among Angelenos for their soccer team, the LA Galaxy, who play their games at the StubHub Center in Carson, south of Downtown.

Every March since 1986, more than 25,000 athletes have signed up to run the 26.2 difficult miles across Los Angeles' urban terrain. The LA Marathon is as popular with supporters who cheer from the sidelines as it is with the dedicated runners themselves.

The Tour of California, held annually in May, is a professional cycling stage race that began in 2006. The eight-day race covers up to 700 miles through the state of California. Cycling enthusiasts and supporters line up along the route, encouraging the cyclists on their journey to finish the arduous and challenging race. Also on wheels, albeit slightly faster paced, is the Grand Prix of Long Beach, an annual two-day IndyCar (formerly Formula One) racing event held beachside that draws an international crowd of over 200,000.

Los Angeles is known for the beautiful beaches of Venice, Santa Monica, and Malibu. Venice is most known for its freewheeling, colorful, and often eccentric Venice Boardwalk, where one can skateboard, rollerblade, or play beach volleyball, as well as watch (or participate with!) the weightlifters/bodybuilders at the body shrine known as Muscle Beach. Santa Monica offers a trendy, hip, and upscale vibe with its smart restaurants, bars, coffeehouses, and chic shops located on the Third Street Promenade, Main Street, and along Montana Avenue. It is the Santa Monica Pier, built in 1909, that is the main attraction, boasting a giant Ferris wheel and carousel, with a dramatic view of Santa Monica Bay. Running and cycling are popular year-round sports; Angelenos enjoy jogging and riding on a myriad of paths throughout the city, which is a terrific way to explore the seaside and surrounding neighborhoods. LA's popular beach life has had a dominant influence on what people think about when they dream of visiting or living in LA. The beach communities of LA embody the dreamy mythology of LA culture and capture the imagination of the world.

Surfing has been synonymous with LA's active and playful lifestyle since the early 1900s, when the railroad magnate Henry Huntington brought a Hawaiian surfing instructor to give surfing demonstrations to promote the completion of his Red Car route. The public-use

rail car was LA's first set of wheels traveling from Downtown to Redondo Beach. Though the Red Car didn't last, surfing, as a sport and culture, certainly has. Up the Pacific Coast Highway (also called Route 1), surfers are visible along Malibu's beaches, most pointedly at the legendary Surfrider Beach, located next to the Malibu Pier. Zuma Beach, a twenty-one-mile stretch of sand with multiple breaks and inlets, produces world-renowned waves.

With more than four thousand acres of parkland, Griffith Park is one of the largest municipal parks in the US, located in the hills above Hollywood, at the eastern end of the Santa Monica Mountains. The park is a perfect place for recreation, and it is special to have a natural wilderness in the heart of LA, providing a haven from the hectic pace of urban life. The park includes LA's famed Art Deco Griffith Observatory (1935), the Los Angeles Zoo, the Gene Autry Western Museum, the Travel Town Museum, the Greek Theatre, a Merry-Go-Round, and many perfect picnic spots, golf courses (there are two), tennis courts, bike paths, and horseback riding and hiking trails.

The Huntington Library, Art Collections, and Botanical Gardens are located in San Marino, next to Pasadena, and boasts 120 acres of beautiful and splendidly themed botanical gardens, including a Japanese garden, a rose garden, and one of the world's largest desert gardens. Angelenos and tourists of all ages come here to relax, stroll the grounds, and revel in their beauty.

Go confidently in the direction of your dreams. Live the life you have imagined. —HENRY DAVID THOREAU

I would not exchange my leisure hours for all the wealth in the world. —HONORÉ DE MIRABEAU

Paris

Just like Los Angeles, Paris has also hosted the Summer Olympics twice. The second summer Olympics, known as the Games of the II Olympiad, were held in Paris in 1900, at the same time as the Exposition Universelle (World's Fair). There were 997 athletes competing from twenty-four nations across nineteen different sports. Paris hosted the games for a second time in 1924, when 3,089 athletes from forty-four nations participated in seventeen sports and 126 events.

Parisians like sports. They support the value of both watching and participating in sporting events, and feel that sports shape the body and sculpt the soul. The top sporting event in Paris is the Roland Garros Tennis Tournament (the French Open), which is held in June and receives worldwide attention. This tennis tournament is the unofficial kickoff to warmer weather and the summer season. The tournament is replete with a touch of glamour and Parisian elegance.

Another top sporting event in Paris is the final stage of the Tour de France cycling race, which takes place at the end of July. The race always ends in Paris, and fans line up on the Champs-Élysées to cheer on the athletes, even though a French cyclist has not won the race in decades.

Parisian joggers and runners are often spotted on the many trails in the Bois de Boulogne and the Bois de Vincennes, as well as in the many parks and gardens created throughout the city from the 1970s through the 1990s. These parks were intended to create green areas in the otherwise building-dense city. The Paris International Marathon, held every April, was established in its current form in 1976 and draws over 40,000 participants running along

its stunning route through the romantic streets and architecture of the city. It is one of the most popular running events in Europe.

Parisians follow their soccer team, the PSG (Paris Saint-Germain), with great enthusiasm at the Parc des Princes Stadium in the 16th arrondissement. They enjoy the tradition of going to the games and socializing with friends, family, and fellow fans. The Stade de France, boasting an elegant elliptical form, was built to host the final of the 1998 Soccer World Cup and resulted in a perfect win for the home nation—France beat Brazil 3–0. Half a million people gathered on the Champs-Élysées to celebrate the victory. The stadium was also the venue of the 2007 Rugby World Cup final.

Parisians are also fond of horse racing. Longchamp Racecourse extends over fifty-seven hectares (about 141 acres) along the Seine in the Bois de Boulogne and hosts the Prix de l'Arc de Triomphe in October. Winning this race is the greatest victory a French jockey can hope to achieve, according to Yves Saint-Martin, a retired jockey who won the race four times. As many as 50,000 spectators attend this event, which makes it one of the major social events in Paris, and evokes a degree of snobbery, glamour, and Parisian sophistication. The race attracts a large number of people who enjoy betting on the horses, as well as a lot of media coverage, making it one of the most prestigious horse races in the world.

Parisians treasure their leisure time and value the importance of living, not just working. Beautiful carousels can be found throughout the city, a delightful reminder of how much fun it is to be carefree and childlike. The Ferris wheel is also a symbol of a Parisian's idea of seeking something greater, endless, and faraway. Parisians indeed feel free and above it all on La Grande Roue de Paris, located in the Place de la Concorde. As you are suspended in one of the forty-two gondolas, the views of the Tuileries Garden and the Louvre, as well as large sections of Paris, are truly spectacular.

The Luxembourg Gardens (le Jardin du Luxembourg) is every Parisian's favorite park. It's a necessary respite and an absolute continuation of the life and activities of Le Rive Gauche (the Left Bank) in Paris. Luxembourg Palace, once the home of Marie de Médicis, is now the French Senate as well as the Musée de Luxembourg, which features spectacular exhibitions. The beautiful gardens provide a comforting place for Parisians to relax and just sit, read, and people watch, or to be more active by walking or jogging. I remember taking my then eight-year-old daughter rollerblading, before rollerblading became popular in Paris, knowing everyone was watching her skating, having fun, and being carefree. Today, thousands of rollerbladers glide through the city streets. The Luxembourg Gardens is a favorite place of sun-worshippers, as

well as the *promeneurs*—those who stroll and enjoy the fresh air.

In 2002, a new concept in urban leisure, Paris Plages, was created along the Seine. For a period of four weeks in the summer, traffic around a segment of the river is closed off so Parisians can enjoy a St. Tropez–inspired beach, complete with sand, parasols, games, drink stands, and even palm trees. Though it is illegal and would be unhealthy to swim in the River Seine, the artificial beach was an immediate success and has now spread to the Bassin de la Villette, where water sports are also organized. Alternatively, there is swimming, enjoyed by many Parisians, offered at the Piscine Joséphine Baker, a floating pool on the Seine in the 13th arrondissement.

You can discover more about a person in one hour of play than in a year of conversation. — PLATO

Dodger Stadium

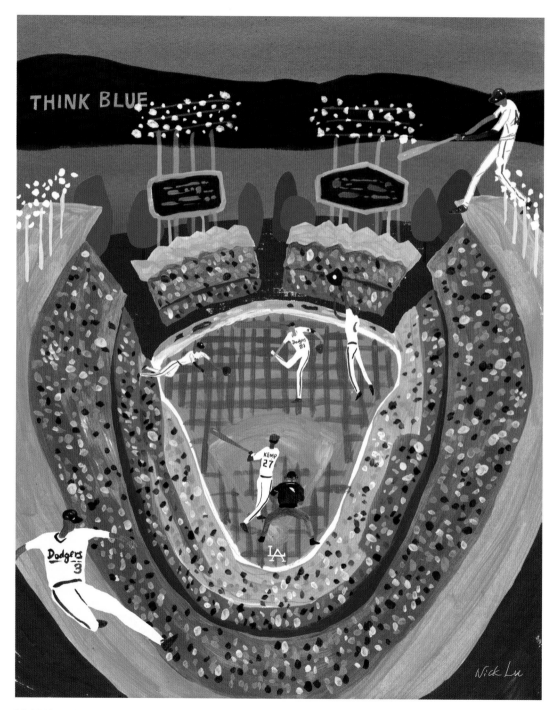

34.0740, -118.2420

If winning isn't everything, why do we keep score? —VINCE LOMBARDI

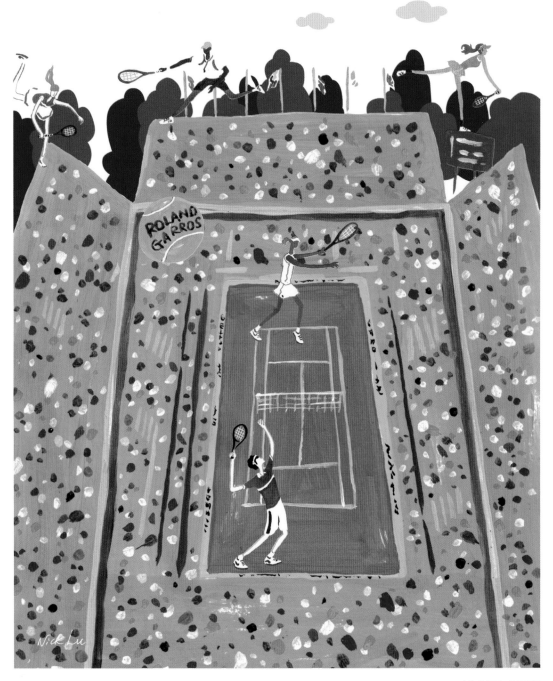

Staples Center

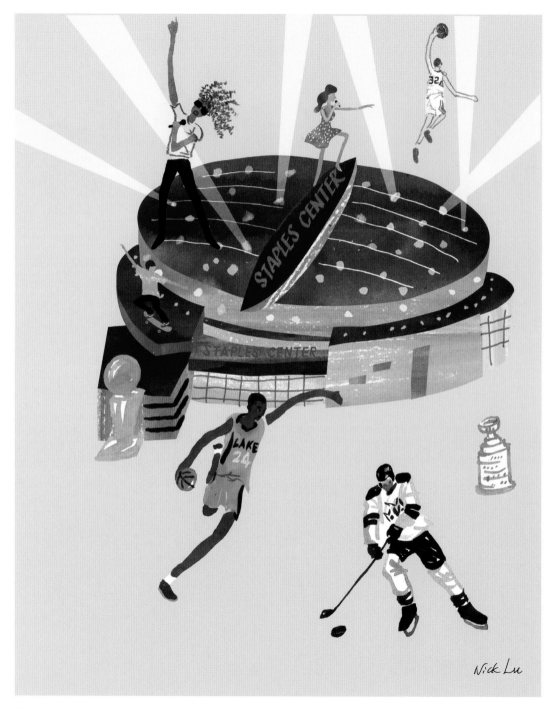

34.0440, -118.2670

Palais Omnisports de Paris-Bercy

The essential is to excite the spectators. —ORSON WELLES

48.8390, 2.3780

SOCCER/FOOTBALL

LA Galaxy, 1996

33.8633, -118.2610

PSG (Paris Saint-Germain), 1970 *Go for the Goal!*

48.8420, 2.2520

Tour of California, 2006

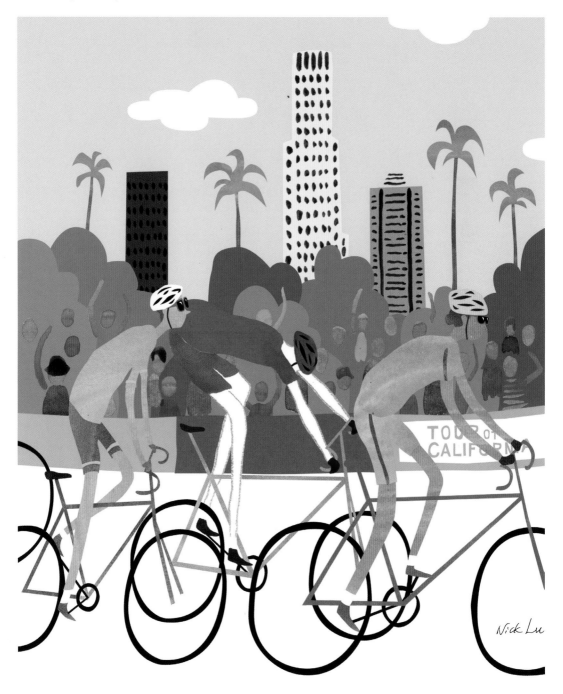

Tour de France, 1903

Life is like riding a bicycle. To keep your balance you must keep moving. —ALBERT EINSTEIN

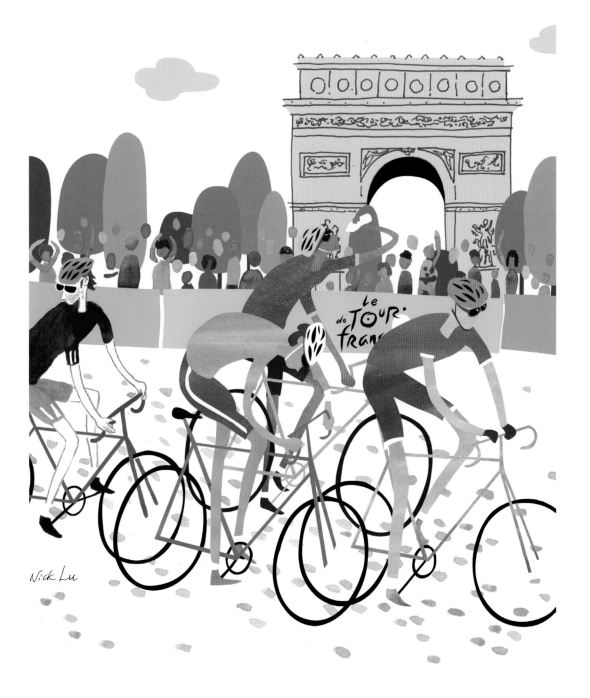

Nick Lu

Los Angeles Marathon, 1986

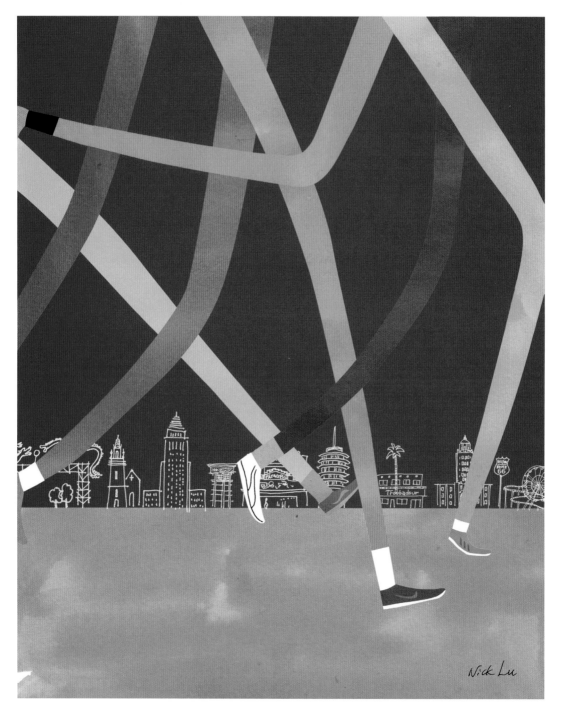

Paris Marathon, 1976

Racing teaches us to challenge ourselves. —PATTISUE PLUMER

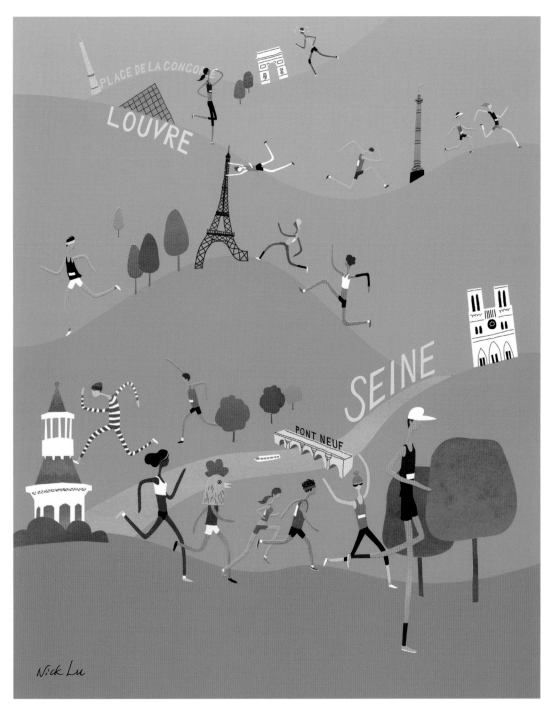

LA Beaches

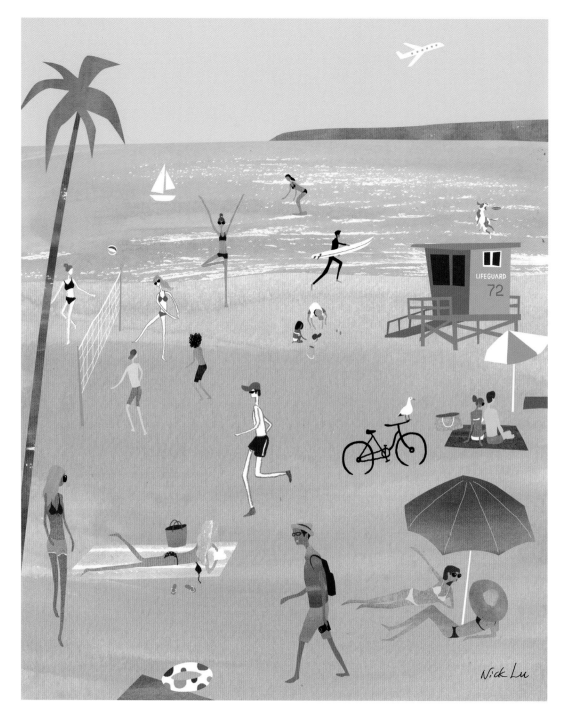

Paris Plages

Beaches are places where people go to have fun . . . in the sun.

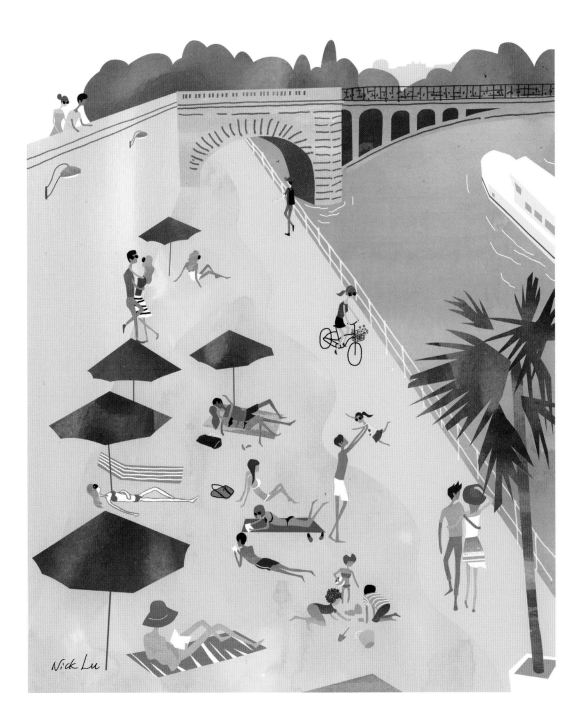

BALANCE

Surf

The best surfer in the world is the guy having the most fun. —PHIL EDWARDS

Ballet

The Huntington Library, Art Collections, and Botanical Gardens, 1919

Nick Lu

34.1308, -118.1104

Jardin du Luxembourg, 1612

City parks are a true retreat for city dwellers.

48.8490, 2.3340

FERRIS WHEELS

Santa Monica Pier, 1996

34.0100, -118.4960

La Grande Roue de Paris
(Place de la Concorde), 2000

I see nothing in space as promising as the view from a Ferris wheel. —E. B. WHITE

Nick Lu

48.8650, 2.3220

STEPS

Los Angeles

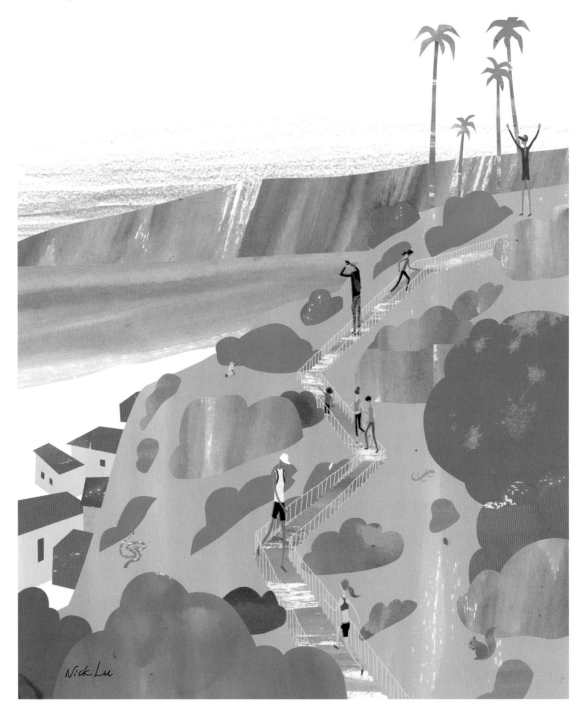

Fitness—if it came in a bottle, everybody would have a great body. —CHER

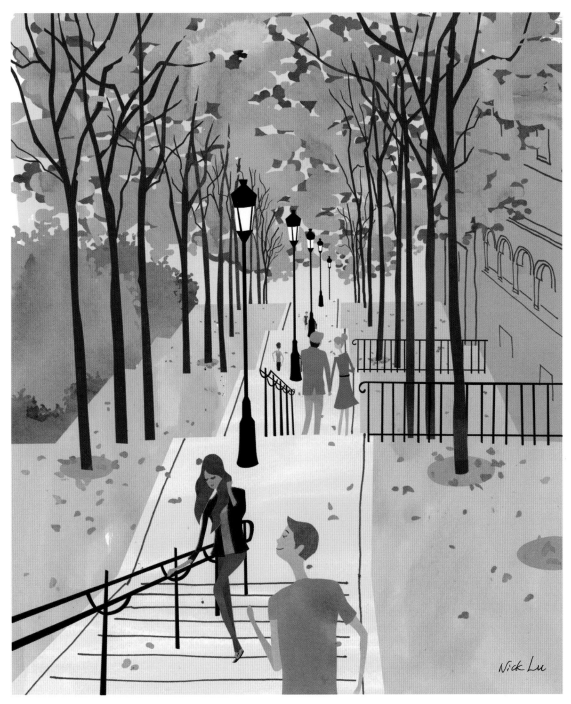

5 Communicating Ideas: Art & Culture

Men come together in cities in order to live, but they remain together in order to live the good life. —ARISTOTLE

LA has a constantly growing and eclectic arts scene with a worldwide audience. The city is home to many cultural hubs and is constantly being reinvented to accommodate its continual transformation and growth. But since LA is a young city, it all started with a rather unique take on architecture.

The Spanish influence and Mission-style architecture of Los Angeles dates back to the eighteenth century and continues to flourish into the twenty-first century, due to the city's discernable Hispanic cultural heritage and population. Victorian-style homes, complete with clapboards, filigree, and porches, dominated architecturally through the turn of the century, just as Greene and Greene debuted their Arts and Crafts–style home, combining natural elements into the exteriors of homes. During the 1920s and 1930s the city saw a building boom of Art Deco department stores, hotels, and office structures along the sixteen-mile Wilshire Boulevard corridor, which stretches from Downtown to the Pacific Ocean. It is the "Art Deco Wonderland" for which LA is so famous. By the 1960s, LA architecture came to be defined by Modernism. Some of the most visionary architects of the twentieth century worked in LA, including Frank Lloyd Wright (Hollyhock House), Rudolph Schindler, Richard Neutra, Charles and Ray Eames (Case Study House No. 8), and John Lautner (the Chemosphere).

An ultra modernist mode of urban planning and architecture gave Downtown Los Angeles a skyline. The Music Center's impressive Dorothy Chandler Pavilion was built in 1964

152

in a restrained blend of classicism and modernity atop Bunker Hill. Its intent was to thrust the city's burgeoning art community into an international spotlight, with theaters worthy of comparison to the world's best. A compelling icon, the Center is the perfect venue for ballets, operas, theater, and symphony orchestras. The Walt Disney Concert Hall, completed in 2003 and designed by Frank Gehry, is a world-renowned architectural masterpiece. It is a place for music and art to flourish, with heavenly acoustics that allow audiences to appreciate a mix of classical and contemporary music.

In its short existence, Los Angeles has become a successful urban archetype set between the mountains and the sea. The City of Angels is now a center for science, aerospace, technology, manufacturing, trade, banking, education, sports, entertainment (television, movies, video games, and recorded music), fashion, media, art, architecture, and tourism. There are now over 840 museums and galleries located throughout the city—more museums per capita than any other city in the world. The Los Angeles County Museum of Art (LACMA), which is located on Wilshire Boulevard (Museum Row) and was redesigned in the mid-2000s by Renzo Piano, contains more than 100,000 art objects. Adjacent to LACMA is the Page Museum at the La Brea Tar Pits, best known for its fossils and diverse collection of local extinct Ice Age plants and animals. It is the geographic center of LA and reflects the city's most distant past.

Overlooking Los Angeles, high atop a hillside in Brentwood on the Westside, is the Getty Center, designed by Richard Meier, which houses billionaire J. Paul Getty's art collection. The stunning flagship building of the Museum of Contemporary Art (MOCA), designed by Arata Isozaki, opened in 1986 and established LA as an internationally recognized center for cutting-edge modernist art. The Norton Simon Museum of Art (1975) in Pasadena, contains one of the finest collections of European, Asian, and American art. The museum's treasures include a beautiful garden and significant pieces of Impressionist art and sculptures displayed in galleries designed by Frank Gehry.

The Pacific Design Center (1975), an icon of contemporary architecture in West Hollywood that was designed by Cesar Pelli, is the premier showcase for all things design in LA. Growing up in this part of the city encouraged my love of creation and design and inspired me to see things in new ways.

World-class fine art is featured at the many art galleries in Downtown LA, Pasadena, Culver City, Beverly Hills, and Santa Monica. Art lovers make their way to the area's top galleries and exhibition spaces, where new and distinguished artists are featured. Feeling free to push barriers and let their minds wander, artists are drawn to LA. As a result, the spirit of

creativity constantly energizes the city.

Opportunities for education and expanding the mind abound in LA. The city is an intellectual and collegiate hub. Adjacent to Downtown, the University of Southern California (USC), built in 1880, is LA's largest private-sector employer. Located in Exposition Park, next to USC's campus, are the California Science Center, the site of the Endeavour Space Shuttle, and the Natural History Museum. Nestled on a 420-acre campus between Westwood and Bel Air is the highly rated University of California, Los Angeles (UCLA), which was founded in 1919 and is one of the nation's top research universities.

All great cities are known for their famous writers. F. Scott Fitzgerald, Nathanael West, Raymond Chandler, Dorothy Parker, John Fante, Ray Bradbury, and James Ellroy all captured the mysterious inner reality of the City of Angels from their own perspectives. Many of these writers' novels have gone on to become movies. In the twentieth century, bookstores were bountiful and writers could find their books, plays, or comics nearly anywhere. Now only a few remain where Angelenos can browse for hours, giving way to electronic media and online content.

Culturally, many Angelenos are driven to be the best they can be—manifested in a way unlike any other city. Here, winner takes all. Angelenos talk freely, almost boastfully, about their successes and achievements in life. This is winning in LA. It is a highly individualistic culture with an emphasis on creative self-expression and freedom. Lots of creative energy is expressed throughout the city in every field. In the Startup Genome's list of the world's top startup ecosystems, LA ranks third, while Paris ranks eleventh. "Silicon Beach" is a term used to describe West Los Angeles and its fast growing technology hub, rivaling "Silicon Valley" in Northern California for entertainment- and social technology–based companies, which seem to be popping up daily throughout the area. In LA, people accept uncertainty more readily and are able to embrace new ideas and innovative products more easily than in a very traditional society. Angelenos are willing to try new things in technology, business, fashion, architecture, and food. There is also an elevated tolerance for ideas, opinions, and freedom of expression. While LA is newer and younger than Paris, the city tends to think BIG.

LA in the twenty-first century has become a world-class city of boundless amenities, providing its consumers with constant stimulation. These urban enjoyments are powerful and help determine the city's success—they attract people to live and work collaboratively and competitively, on the basis of pleasure as well as productivity. In this way, Los Angeles will remain a fertile environment for creativity and an engine of innovation.

Boldness has genius, power, and magic in it.
—JOHANN WOLFGANG VON GOETHE

Creativity is intelligence having fun. —ALBERT EINSTEIN

Paris

Above all, there is a quality of life in Paris that fulfills the deepest and most varied needs of the human spirit. Paris has long attracted talent to live, study, and find inspiration. The idea of time and certainty is found in the sentiment of a people with a rich, historical past of great strength and courage. Even through world wars, revolutions, and upheavals, Parisians have repeatedly overcome challenges and adversity while retaining their culture, values, allure, and mystique. Goethe described Paris as a "universal city where every step upon a bridge or a square recalls a great past, where a fragment of history is unrolled at the corner of every street." Every day, the past becomes mixed with the present in a city that always manages to reinvent itself and find new ways for Parisians and visitors alike to experience *joie de vivre*, a joy of living.

In a city also known as the City of Love, Parisians love life, enjoy expressing their emotions, and feel connected to each other, to the world community, and to nature. This love of life is especially evident at the Pont des Arts—a pedestrian bridge where couples write their names on a padlock, attach it to the bridge, and throw the keys in the Seine. Romance is embodied in this city, and everywhere you look you will see couples kissing and embracing in the streets, gazing into each other's eyes at cafés, and walking hand-in-hand, and even acquaintances kissing on each cheek when they greet each other. Sensuality is fundamental, and there is a premium put on experiencing pleasure in ordinary and extraordinary moments.

Paris' architecture and buildings make your heart soar in the rhythm of their repetitive and evolving styles. In the eleventh century, the construction of many buildings in the Romanesque style began. The Saint-Germain-des-Prés Church, situated in the heart of the Left Bank, is a perfect example of this style of architecture. In the fourteenth century, a new Gothic style

appeared with the Cathédrale Notre-Dame de Paris. The Renaissance style of the sixteenth century initiated the concept of Classical architecture in Paris. Neighborhoods that were developed in this style include Le Marais, the Latin Quarter, Faubourg Saint-Germain, and the Palais-Royal (Rue Saint-Honoré). Architecture became almost pictorial with the advent of the Baroque influence from the sixteenth to the eighteenth century. This style is featured in the Palais du Luxembourg, and the many buildings designed by François Mansart—the creator of the distinctive double-sloped mansard roof, for which the city's skyline is best known.

The Élysée Palace, home of the president of France, is an example of the Rococo style of architecture prevalent in the eighteenth century. In the late eighteenth and early nineteenth centuries, Paris entered a period of Neoclassical architecture. Napoleon used this style extensively for monumental architecture intended to embody the grandeur of the city. The best expressions of this mode include the Arc de Triomphe, the Palais Garnier, the Église Saint-Sulpice, the Panthéon, and the Madeleine, all famous landmarks. The Haussmannian style, with its façades of pure sandstone, was introduced in 1853 and makes Paris unique. The Art Nouveau and Art Deco styles, used in Paris architecture in the twentieth century, influenced the design of the Musée d'Orsay, the Grand Palais, and many ornate Parisian brasseries and Métro entrances. Contemporary design in Paris emerged in the twentieth century with the radical architectural statement of the Centre Pompidou, which was unveiled in 1977 and is now an iconic landmark. Throughout time, the architecture in Paris has sustained a particular elegance and coherence, which makes the City of Light so very beautiful.

The museums in Paris are among the richest in the world, with artwork representing the best of every historical period, from Roman to Postmodernism. Viewing art and sculpture is an integral part of Parisians' leisure time and daily routine. Sculpture and art are everywhere in the city—built into every lamp post, sign, grate, manhole, square, and corner. Though Parisians are surrounded by beauty, it is far from mundane and only serves as a reminder of the city's keen sense for aesthetics.

The Louvre, first constructed as a fortress in the twelfth century, became a museum in 1793 and is divided into three sections (wings). The Mona Lisa painting, by Leonardo da Vinci, is one of the key attractions. Across the river is the Musée d'Orsay, which was converted from a train station into a museum, and is home to the most important collections of paintings of the Impressionism, Post-Impressionism, and Art Nouveau movements. The Palais de Tokyo, created for the 1937 International Art and Technical Exhibition, is home to the Musée d'Art Moderne and is filled with works from the artistic movements of the twentieth and twenty-first

centuries. The Centre Pompidou, also known as the Centre Beaubourg, is known for its out-standing collections of modern art and its extraordinary exhibitions. The Musée Marmottan Monet, situated near the Bois de Boulogne, has the world's largest collection of art by Impressionist painter Claude Monet. One of the most interesting places in Paris, Les Catacombes, is filled with the bones and skulls of millions of Parisians whose bodies were exhumed as a solution for Paris's overflowing cemeteries. During WWII, these tunnels were used by members of the French Resistance (the underground army).

Education is a priority to Parisians, and academic performance is a key determinant of success. The University of Paris, situated in the Rive Gauche area known as the Latin Quarter, became famous in the thirteenth century for classes that were taught in Latin. The historic institution was renamed Paris-Sorbonne University and reorganized in 1970 into thirteen autonomous schools. Saint-Germain-des-Prés is the hub of the city's intellectual life.

Paris has an extraordinary literary history. The city has nurtured countless French writers over the centuries who, together with ex-pat writers who journeyed to Paris, created the city's legendary literary reputation. Writers like Sidonie-Gabrielle Colette, Marcel Proust, Émile Zola, Honoré de Balzac, Guy de Maupassant, Jean-Paul Sartre, Simone de Beauvoir, Ernest Hemingway, James Joyce, Oscar Wilde, and George Orwell, just to name a few, are memorialized in the many cafés, bars, and restaurants that used to be their meeting points. One can embrace their words from the past in the present by visiting some of the same places they frequented, such as Les Deux Magots, Café de Flore, la Coupole, or Brasserie Lipp. It is here in the heart of Saint-Germain-des-Prés, that Parisians take full advantage of being Parisian.

Paris is full of atmospheric bookshops, such as the famed Shakespeare and Company, and boasts the highest number of bookstores of any one city in the world. Lining both banks of the Seine, the open-air Bouquinistes stalls, which sell second-hand books, rare magazines, postcards, and old advertising posters, are a definitive Parisian experience. The name comes from *bouquiner*, which means to read constantly (with pleasure).

Paris, with its long history, is very proud of its glory and accomplishments on the world stage. Parisians are traditional in their outlook, and are able to acknowledge inequalities. Power is centralized and formal. Planning is favored, expertise is welcome, and change is viewed as stressful. The focus is on the quality of life—people work to live, rather than live to work (as in LA), and material signs of success are looked down upon.

A city such as Paris embodies the spirit of its people.

As an artist *one has no home in Europe, except Paris….*
— FRIEDRICH NIETZSCHE

LACMA, 1961

34.0640, -118.3594

Louvre, 1793

Form and function should be one, joined in a spiritual union. —FRANK LLOYD WRIGHT

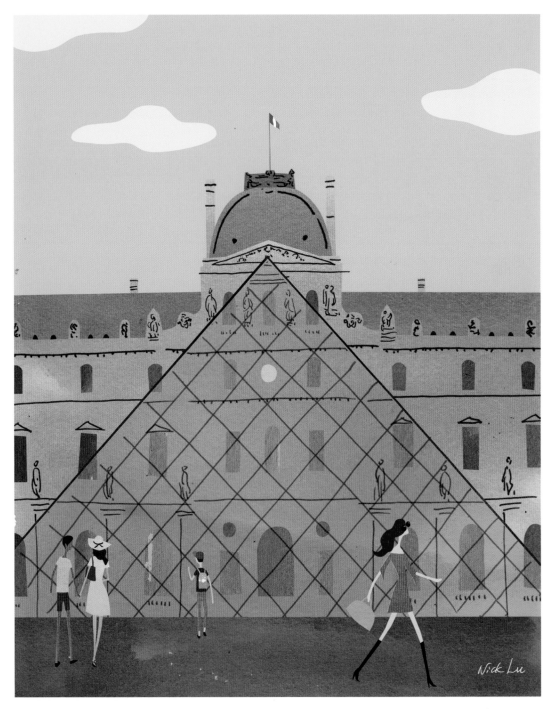

48.8620, 2.3330

Nick Lu

Musée d'Orsay, 1986

Architecture is the reaching out for the truth. —LOUIS KAHN

48.8610, 2.3255

Page Museum at the La Brea Tar Pits, 1975

34.0636, -118.3556

Catacombes, 1814

Fossils unveil the mysteries of life on earth.

Pacific Design Center, 1975

34.0821, -118.3824

Centre Pompidou, 1977

A museum is a place where one should lose one's head. —RENZO PIANO

48.8610, 2.3520

CONTEMPORARY ART

MOCA, 1979

Nick Lu

34.0530, -118.2500

Palais de Tokyo, 2002

Art is anything you can get away with.
—MARSHALL MCLUHAN

Nick Lu

48.8650, 2.2970

Norton Simon Museum, 1975

34.1456, -118.1587

Musée Marmottan Monet, 1934

In art new ways of seeing mean new ways of feeling. —DAVID HOCKNEY

48.8592, 2.2676

Graffiti

*The art of a people is a true mirror
to their minds.* —JAWAHARLAL NEHRU

Nick Lu

Murals

8e Arrt
RUE
ROYALE

Nick Lu

Space Shuttle Endeavour, retired in 2012

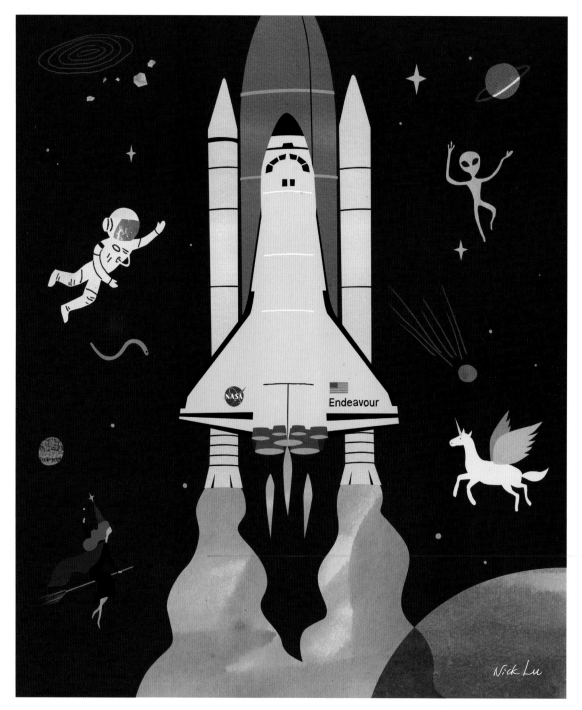

Concorde, retired in 2003

We're completing a chapter of a journey that will never end. —CHRIS FERGUSON, COMMANDER FOR ATLANTIS SPACE SHUTTLE

Nick Lu

48.9365, 2.4258

Barnes & Noble

Les Bouquinistes

You cannot open a book without learning something. — CONFUCIUS

Nick Lu

Kiosks

6 Cuisine & Dining

Food should be fun. —THOMAS KELLER

LA Angelenos have a passionate interest in food—it's no coincidence that the term "foodie" has gained great popularity here. LA cuisine is fresh, seasonal, inventive, and caters to the health-conscious. With a diverse population, varied ethnic cuisines are available everywhere, making culinary adventures possible at all times. The city offers chefs the freedom to experiment, be creative, and to entertain, using ethnic cuisines as inspiration. There is a certain looseness, made possible by the city's landscape, climate, and economy. The influence of LA's food culture on the broader culinary scene affects the worldwide food movement.

Food is connected to the way people live here. Unencumbered by tradition, the LA restaurant universe offers unparalleled casualness that is often taken for granted. A growing number of venerated chefs have opened informal restaurants as part of a pattern of changing tastes and social hierarchies. There is a convergence of the haute and the ordinary, and a mix of the best and the commonplace.

The rise of creative, improvisational cooking with authentic street food has had a dramatic impact on the food scene in the city. LA's ethnic cuisine, including Mexican, Chinese, Korean, Japanese, Thai, and Indian, is authentic and a result of LA's distinctive diversity. In LA, the food scene draws its inspirations from the city's immigrant communities, making it a trendsetter in the food world. It is the birthplace of food trucks, like that of Roy Choi, a young chef who achieved instant fame through the launch of the Kogi BBQ Truck, featuring an

ethnic-fusion dish known as the Korean Taco. This initiated a craze of gourmet food trucks of every conceivable theme, which roam the streets of the city, providing Angelenos with convenient, inventive, delicious food, and even entertainment.

Los Angeles is a playground for world-class chefs to show off to an influential and appreciative audience. There is never a shortage of Angelenos who will spend money on an impressive meal, and knowing this inspires the chefs to follow the highest standards of quality and creativity in their dishes.

Chef Wolfgang Puck is a legend. His first eatery, Spago in Beverly Hills, has remained a mainstay of his now-famous California cuisine, stylishly presented with a nod to French Nouvelle cuisine. Puck, recognizing the rise of a new dining sensibility, has opened informal and more casual types of restaurants. Foods that are meaningful, and an emblem of American culture, such as hamburgers, hot dogs, tacos, pizza, and salads, have become playthings for Puck, as well as other leading gourmet chefs. Opening more casual restaurants offers a form of creative freedom for a chef, and makes it easier for diners to experience the dishes without formality.

When Chef Thomas Keller opened Bouchon in Beverly Hills, he did so to offer casual, classic French bistro cuisine to his guests, and it has become a favorite place for celebrities to dine. A collaboration between well-known chefs Nancy Silverton and Mario Batali has created contemporary Italian perfection in their restaurant Osteria Mozza on Melrose, as well as their more casual restaurant, Pizzeria Mozza. Foodies who love Japanese fusion cuisine adore Nobu and the artistry of its famous chef, Nobu Matsuhisa. With three locations in Los Angeles, all designed by French interior design master Philippe Starck, it is a favorite of stars, politicos, and sushi-lovers alike. Never have we had so many interesting dining choices—comfort food prepared by classically trained chefs and gourmet food prepared in a more casual style. There is a dining revolution happening that is redefining the entire paradigm of how and what we eat.

Angelenos love chefs. They are looked at as true artists. When celebrity chefs open casual versions of their upscale restaurants, they create décors with casually sophisticated designs and dress the waitstaff to match. Stylish looks for the servers are part of the ambiance. Service in LA reflects the atmosphere of the city itself—easygoing and casual. The staffs pair culinary knowledge with a relaxed and inviting manner. The waiters in LA are usually part-time, young, and aspiring actors and actresses.

Perhaps it is not surprising that in such a culturally diverse city, American comfort

food leads the food trends. Comfort food blankets over differences. Rush Street in Culver City and Tavern in Brentwood prepare robust, old-fashioned foods with a twist in a trendy setting. Some of LA's most iconic restaurants also reflect this cooking style. Philippe the Original, located downtown, is one of the oldest restaurants in the city and is most famous for its French dipped sandwiches. Roscoe's House of Chicken and Waffles, with several locations in the city, serves up comfort food and is one of President Obama's stops when he visits LA. Pink's Hot Dogs, famous for its long lines and foot-long hot dogs, is the undisputed choice of stars, making it an entertaining place to people watch. Canter's Deli, in the Fairfax District, is a classic Jewish deli that is a holdover from a bygone era and a 24-hour spot with universal appeal.

Some popular casual dining restaurant chains that are innovative and commercial, such as The Cheesecake Factory and California Pizza Kitchen (CPK), began and are headquartered in Los Angeles. Known for their creative dishes and for making dining a pleasurable experience, the restaurants have a cross-cultural appeal and are located throughout the city, as well as the country.

In-N-Out Burger, a famous drive-through restaurant that was founded in 1948, is best known for its Double-Doubles and Animal-style fries. Though the cheap eat is a SoCal mainstay, one restaurant after another is vying for the claim of having the most luxurious burger. This epitomizes the approach to making common foods gourmet. Umami Burger and The Counter are hamburger places located throughout the city that are part of this trend and reflect the eclectic style of individual chefs.

One of the best places to get a burger in LA is right in one's own backyard. Often in Los Angeles, people like to entertain by having BBQs. They gather in one's backyard, a park, or even at the beach, to cook food on a grill and eat in the most casual of fashions—an appealing way to get together with family and friends. In addition to hamburgers, typical menus might include hot dogs, chicken, steak, corn on the cob, salad, and dessert. The food fare can also be more complex, depending on the variety of individual styles. With LA's outdoor lifestyle and abundance of nice weather, sun, and beautiful houses, it is no wonder grilling is thriving as a way to have fun, enjoy food, and entertain guests.

The best quality ingredients are a must for chefs to prepare their exceptional dishes. Thanks to the region's climate, fresh ingredients are readily available at the many farmers' markets throughout the city, and the variety of food available is impressive. LA is blessed with great weather year-round, which makes for bountiful crops. Local farmers and vendors sell fresh and organic foods. No doubt the city's best chefs shop at these markets. A long-time

favorite with Angelenos and visitors is the famous Wilshire Center Farmers' Market. It has more than 160 stands offering a variety of fresh produce, flowers, specialty foods, and gift items.

LA's coffee culture is all about the experience of getting the best cup of coffee. Coffee is a priority for Angelenos, and an excellent cup is available on nearly every street corner in the city. Coffee chains such as Starbucks and LA's own The Coffee Bean & Tea Leaf are the most prevalent and popular. But, real zealots can be found at LAMILL Coffee in Silver Lake and Intelligentsia in Silver Lake, Pasadena, Culver City, and Venice. Stumptown Coffee Roasters, G&B Coffee, and Handsome Coffee Roasters offer the best brews in Downtown LA, while Cognoscenti Coffee is one of the Westside's best. Getting coffee in LA is all about the experience, the social interaction of meeting people, taking a break, relaxing, and socializing.

Ice cream in Los Angeles is a mixture of the old and the new. Baskin-Robbins started in Glendale, a suburb, in 1953, and has grown to become the world's largest chain of ice cream specialty stores. Many other trendy and unique ice cream parlors and frozen yogurt establishments are found all over the city. And in a city with a climate like LA's, they are busy year-round offering cool and delicious treats.

Each neighborhood has its own style and vibe, and their eateries reflect the local population. At the Malibu Country Mart you can dine, shop, and watch celebs go by. Pasadena, birthplace of the late Julia Child, author of the famous book *Mastering the Art of French Cooking*, has become a dining destination in LA, with about 500 eateries (more restaurants per capita than New York City), according to the *LA Times*. Los Angeles overflows with eating and drinking pleasures, from the gourmet to the casual.

If you are what you eat, then I only want to eat the good stuff.
—REMY FROM DISNEY'S *RATATOUILLE*

Paris

Food brings out the best in Parisians. The city is thought by many to have the best cuisine in the world. If there is one thing Parisians care about, it is their food.

Paris is not generally a producer—it is where products from all over the world converge. It is here that the respective qualities of every type of food are most appreciated, and put to the best use, to satisfy Parisians' sensuality.

French haute cuisine is a cooking style that became famous in the 1900s. It is primarily a Parisian phenomenon, and is best described as the meticulous preparation and presentation of food and wine. Nouvelle cuisine, also a Parisian cooking trend, emerged in the 1960s and emphasizes natural flavors—using the best possible ingredients and creating inventive pairings in the dishes that are served. Cuisine bourgeoise is home-style cooking, with a focus on fresh ingredients and integrity in each taste, and it can be found at many local bistros in Paris.

Le marché, the market, is a typical Parisian experience. At the marchés, the buyers inspect the merchandise, gauging its quality and freshness while looking through the vast selection of foods to choose from the baskets and mountains of vegetables. Parisians love le marché. They offer simple versions of a Paris wonderland—discreet perfection. Parisians enjoy the charms of their local marché with its characteristic colors, smells, textures, and sounds. Le marché evokes a form of timeless simplicity, and going is a treat that allows one to connect with simple pleasures.

While some Parisians shop for food at the supermarket, they prefer to go to the marchés early in the morning to get the best groceries, even though the best prices are to be had when

the markets are closing. Supermarkets, or *supermarchés* in French, are small by LA standards, and are convenient, practical, and utilitarian. Shopping carts are small. Service is minimal, with shoppers having to move around crates of stacked merchandise in the middle of the aisles. Checking out can be a nightmare; you have to bag your own groceries and they can get mixed up with those of other customers. Parisians do not seem to mind, though; the supermarkets are this way because Parisians more often go to the outdoor markets and small shops for their food needs, and do not give too much thought to the supermarket experience.

Discerning chefs are to be found at the President Wilson Open-Air Food Market near the Trocadéro. This marvelous marché is situated on a boulevard surrounded by Acacia trees and beautiful residential buildings with mansard roofs and wrought iron balconies. The aromas draw you in to the market stalls, abounding with fresh produce, meats, pastries, artisanal cheeses, pasta, nuts, and even crêpes. But perhaps the most visually striking stalls are those overflowing with beautifully displayed stacks upon stacks of fresh flowers. Everyone searches for the best ingredients and then returns to their kitchens to prepare the food.

In Paris, dining together is a ritual. It offers the combined opportunity for good food and good conversation. Everything connected with dinner parties in Paris takes on an almost sacred importance. The quality of cooking comes first, and then comes the quality of the guests and conversation. The meal consists of the best and truest ingredients one can afford, and dining consists of the best each party can bring to the experience—from the food to the talk. In addition to the carefully chosen guests are the carefully selected wines, breads, cheeses, coffees, desserts, and table decorations. Parisians know how to do more with less and know there is a right moment for all things.

A meal should delight the senses, and to be enjoyed it must be both pleasing to the eye and thrilling to the palate. Restaurants are like theaters; they have their stage and their backstage.

Alain Ducasse is a star chef and the epitome of Parisian excellence. He has probably done more to promote Parisian cooking around the world than any other living chef. He chooses the best ingredients, hires the best staff, and creates a magnificent décor that is reflected in the restaurant of the Hôtel Plaza Athénée. Ducasse's attention to detail makes the dining experience unforgettable. In 1998, he opened Spoon Food & Wine, a smart-casual bistro that allows guests to mix and match dishes. The concept, a trend that actually began in Los Angeles with Wolfgang Puck, was a hit with the fashionable jet-set crowd.

Paris cafés, bistros, brasseries, and restaurants breathe so much history. These are

places where Jean-Paul Sartre, Ernest Hemingway, James Joyce, and Pablo Picasso came to eat and think. Many of these bistros remain in the Art Deco or Art Nouveau style, like Café de Flore, Brasserie Lipp, Les Deux Magots, Brasserie Balzar, and La Coupole. Large mirrors line the upper half of walls, dark wood paneling wraps the bottom half, and white and green tiles line the floors. They are best known for their classical French cuisine: *foie gras, escargot, salade au chèvre chaud, choucroute, steak frites, sole meunière, plateaux de fruits de mer, poulet rôti, mille-feuille*, and *moelleux au chocolat*. The meal is always accompanied by fresh, daily-made baguettes; the perfect accompaniment for any dish on the menu.

Perhaps best at marrying the old with the new is Café Marly, one of the Costes brothers' many Parisian hospitality success stories. The terrace of the café offers a spectacular view of I. M. Pei's glass pyramid at the Louvre. The restaurant features fashionable cuisine that is light and healthy. Another Costes creation, L'Avenue, is located on the celebrated Avenue Montaigne. It is frequented by celebrities, as it's the perfect hideaway, just off the Champs-Élysées. The interiors of both are trendy and chic. Both are places to see and be seen. In a Parisian restaurant, the table to which the guest is shown is sometimes important—it can say everything about his or her status.

Dining in a restaurant that has a stunning view of the city is an added attraction to the dining out experience. Located on the sixth floor of the Centre Pompidou is Le Georges, which has a breathtaking view of the rooftops and skyline of Paris. If you can reserve a table at sunset, you won't bat an eye at the final check. And then there is the legendary Le Jules Verne, in the Eiffel Tower, for those who want to experience the ultimate in luxury. Not a single detail is missed at Le Jules Verne, lifting the bar of service higher than La Tour Eiffel itself.

Parisians love *sucreries* (sweet things), and the window displays at the pastry shops are truly irresistible. Ladurée is the most decadent of the Parisian *pâtisseries*, known best for its invention of the *macaron*, a traditional light-as-air almond- and sugar-based sandwich cookie flavored with ingredients du jour. Parisians visit the *salon de thé* (tearoom), but also purchase them to go. Ladurée macarons are a delicious treat as gifts, and they not only delight the recipient but also assert the giver's social value. Ladurée delivers with limited-edition and one-of-a-kind collectible packaging to keep long after the incomparable macarons are gone.

Parisians stand in line for a *cône de glace* or sorbet at Berthillon on the Île Saint-Louis, where they believe the best ice cream in the world is made. Standing in line is good—it gives Parisians a chance to decide which flavor and how many *boules* (scoops) they want.

Burgers are now flourishing on the menus of many Paris bistros and restaurants, and

are considered to be hip and cool. It is interesting that in a city devoted to fine dining, gourmet burgers have caught on in such a big way. One of the best burgers in Paris is at Café Louise, a charming place on the Boulevard Saint-Germain. Also in the 6th arrondissement is Coffee Parisien. But don't let its name fool you—it's less known for its great coffee than it is for its incredible burgers and lively setting. The 9th arrondissement features Big Fernand, an "atelier du hamburger" (hamburger workshop) where you can design your own burger.

The level of service in a café, bistro, or restaurant is very important to Parisians, and the standards are very high and often difficult to live up to. The waiters in Paris are professional, serious about what they do, most often dressed formally in tuxedos, and carry themselves with pride. Yet they don't always like being ordered around and can find themselves getting too easily frustrated when little things do not live up to their incredibly high standards. This passive-aggressiveness many times translates to the customer, and Parisians are often caught up in a whirlwind of reciprocal passive aggression. But, on a good day, the interaction can be fun, especially if the waiter or client tells a dirty joke. Waiters in Paris do joke around, in spite of how serious they are about their service.

When you think Paris, think wine and cheese. Parisians love their cheese, and over 500 varieties are available in the many *fromageries* (cheese shops) in the city. The cheese course is an option on nearly every menu in every eatery, and every home is stocked with several varieties. French cheeses are truly special. Each cheese is distinct and appealing in its own particular way, whether aged and earthy or ripe and runny. It is not possible to pass a cheese shop in Paris without smelling the pungent air outside the door. And coupled with the fantastic selection of local wines available, it is possible to experience a match made in heaven every day. Parisian table wine, though inexpensive, is perhaps the worst quality of all Parisian wines—yet still absolutely fantastic. Most restaurants hire a sommelier to pick the wines, help customers choose, and find the perfect pairings of delightful flavors that continue to linger in your mind. For Parisians, these are *de rigueur*.

By becoming immersed in the Parisian experience of food and dining out, one can feel the energy of life that covers a range of moods and experiences. Indulging in Parisian cuisine, in all of its rich and decadent glory, is a must. Taking a table at a Paris café with your morning café noir and croissant and watching the city moving around you is one of life's greatest pleasures.

Maybe life itself is the proper binge. —JULIA CHILD

Wolfgang Puck

*Cooking is like painting or writing a
song . . . it's how you combine the
flavors that set you apart.*
—WOLFGANG PUCK

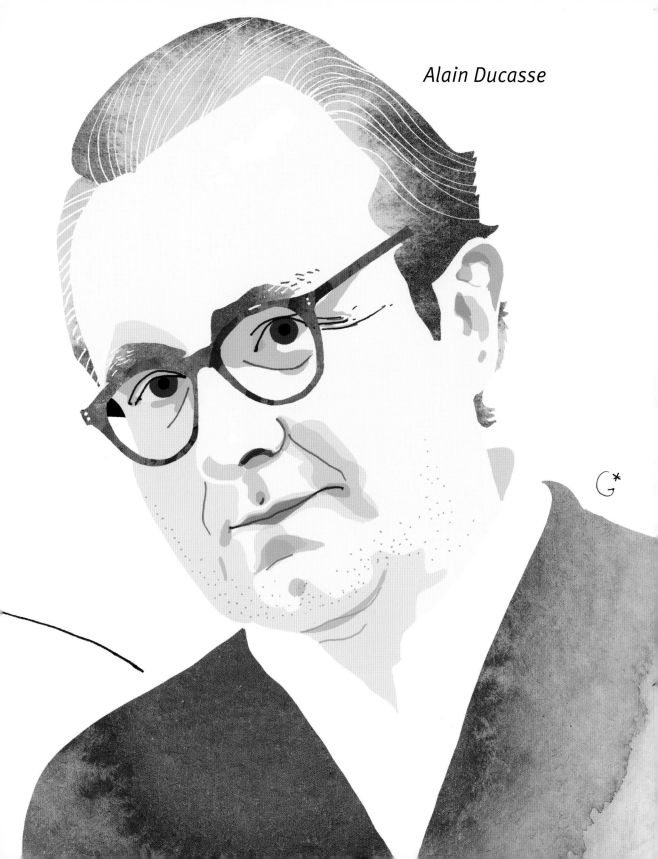

Alain Ducasse

LAMILL, 2008

34.0293, -118.3744

Café de Flore, 1887

Be a coffee drinking individual—
espresso yourself!

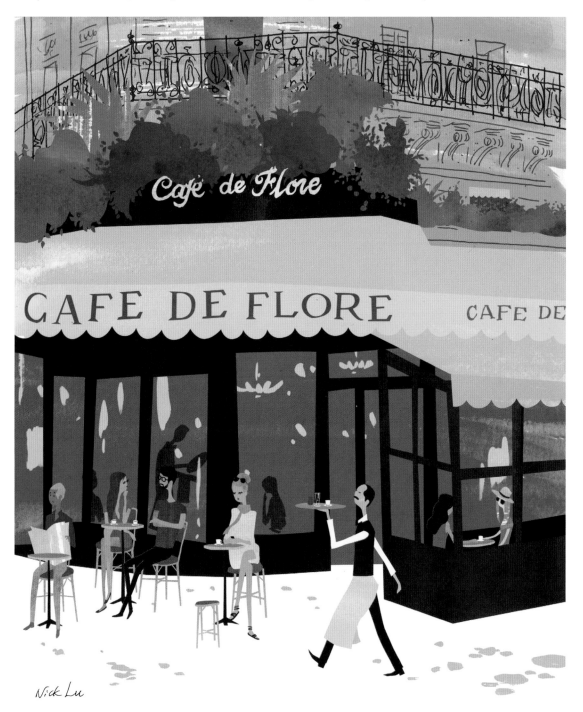

Nick Lu

48.8541, 2.3327

WAITERS

Actors/Actresses

Serveurs

Randy's Donuts, 1953

33.9616, -118.3703

Ladurée, 1862

The only way to get rid of a temptation is to yield to it.
—OSCAR WILDE

G*

El Cholo, 1923

34.0502, -118.3091

Brasserie Lipp, 1880

Great works are often born . . . in a restaurant's revolving door. —ALBERT CAMUS

Nick Lu

48.8539, 2.3325

See's Candies, 1921

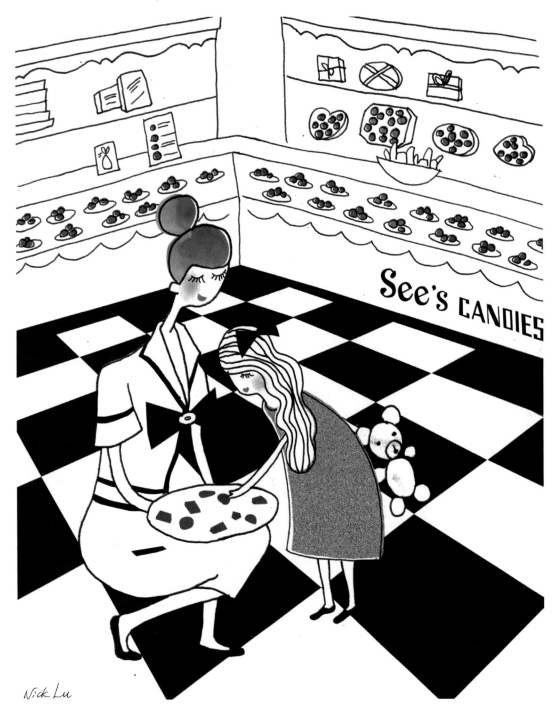

La Maison du Chocolat, 1977

All you need is love. But a little chocolate now and then doesn't hurt.
—CHARLES M. SCHULZ

ICE CREAM/CÔNE DE GLACE

Baskin-Robbins, 1945

Berthillon, 1954

Ice cream is exquisite. What a pity it isn't illegal. —VOLTAIRE

The Farmers Market, 1934

34.0716, -118.3600

Le Marché

[At] farmer's markets, you're creating community around food. —BRYANT TERRY

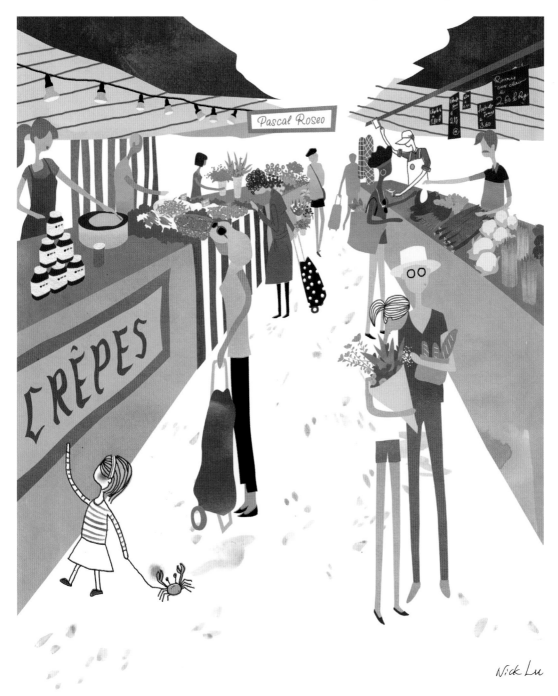

Cheese

Life is great;
cheese makes it better.
—AVERY AAMES

Nick Lu

Fromage

Nick Lu

BevMo!

VODKA

WINE

BEER

Nick Lu

Wine is bottled poetry. —ROBERT LOUIS STEVENSON

7 Cities in Motion

Modern sprawl is the child of the automobile.

—EDWARD GLAESER

LA After California became a state in 1850, Los Angeles grew and expanded quickly and was soon incorporated as a city. In order to accommodate the significant population growth that came from the mass arrival of Easterners and Midwesterners seeking healthier lifestyles and opportunities, the development of an infrastructure was crucial.

A forty-three-mile waterfront area in San Pedro, twenty miles south of Downtown, was transformed into the Port of Los Angeles in the early 1900s, enabling the city to become a major world shipping center and the busiest container port in the US. Arranging for a larger water supply to come from the Owens Valley 233 miles north of the city, by means of an aqueduct system created by William Mulholland in 1913, was critical for turning LA into a larger metropolis.

Los Angeles flourished from the growth of agriculture and especially from citrus production. Oil proved as important as oranges, and soon the landscape was peppered with oil pumps, making Edward Doheny and J. Paul Getty, both industrialists, very wealthy individuals.

A new, thriving aviation industry consolidated itself in 1910, strengthening through the World Wars as a major center for the country's aerospace and defense industries. Aviation dominated the city's economy for decades, leading to the development of the space-exploration focused Jet Propulsion Laboratory (JPL), an outgrowth of the famous California Institute

of Technology (Caltech) in Pasadena, as well as the AERO Institute, RAND Corporation, and SpaceX, amongst others.

The motion picture industry, so closely tied to the identity of the city, fueled growth throughout the twentieth century, as did the apparel manufacturing, fashion, and leisure-wear industries. The rise of these enterprises kept dreams of the future alive.

As the city continued to expand, periodic real estate booms led to subdivisions of old ranchos into smaller and more profitable parcels. The population swelled from approximately one million in 1930 to just about two million in 1950. Three decades later there were three million people, and the present population of almost four million stabilized, more or less, by the year 2000.

We build a city a month out here. —W. P. WHITSETT

Given this phenomenal growth, the 1950s saw the construction of a vast new freeway network that allowed Angelenos to connect from place to place and brought about an auto-based way of life. Los Angeles is enormous, and a complicated network of boulevards and freeways, which are challenging to navigate, link its many neighborhoods. LA has over five million automobiles driving on more than 500 miles of freeways and intertwining interchanges. Cars are a necessity and people spend a lot of time in them. It's no wonder that the automobile has become an integral part of the average Angeleno's identity. This identity is often expressed through the cars themselves and details such as personalized license plates. Hybrids are the new trend, as they are green and economical—especially now that the price of gas has gone up (although it remains less expensive than in Paris). But whether the latest trendy convertible, a sporty SUV, a sturdy pickup truck, a pristine vintage car, or an old jalopy, all these automobiles on the roads result in lots of traffic and congestion, not to mention road rage.

Given that LA is a city that was built to accommodate the automobile, the idea of cruising with the top down and music turned up has been portrayed worldwide in art and cinema. LA's car culture is evident with the number of car rentals, car washes, car dealerships, collision centers, and the city's ubiquitous valet parking—every Angeleno's lifesaver.

Every road traveled is replete with interesting sights to behold. From old to new, the forever-changing landscape of the city always offers surprises—diverse architecture, a wealth of natural beauty, and awe-inspiring views. Nowhere is this more evident than driving down Sunset or Wilshire Boulevards to the ocean, cruising PCH, or winding through the hillside

roads of Topanga, Laurel, Coldwater, or Benedict Canyons—presenting sublime and magical moments of changing and irresistible landscapes.

Even though people will always say nobody walks in LA, there are plenty of walkable areas of the city, and walking works well in specific communities. However, distances are often just too great between where you are and where you may want to go. In LA, you drive to walk and walk to forget that you drove! Walking, though, is the best way to explore the intricacies and uniqueness of the neighborhoods that make up the city.

Biking offers a different way to experience the city, allowing you to see things you might otherwise miss. It may also save time and money and helps people stay fit. As the trend escalates in popularity, the city is accommodating it by building a 1,680-mile bikeway system to make LA more biker-friendly.

For those who do not wish to drive or bike, the Metro is made up of buses, subways, and light rail trains, and is surprisingly efficient with six metro lines and about eighty stations. The stations are each unique and are adorned with artwork and sculptures. Navigating the city is always a challenge and takes planning and foresight.

As a mixture of the Mission Revival, Southwest, Spanish, and Art Deco styles, Union Station is an impressive architectural landmark in Downtown Los Angeles and has stood as a monument to the "Golden Age" of railways since its construction in the 1930s. It is the heart of the region's public transit system, serving as the confluence for Amtrak, Metrolink, and Metro Line commuter trains.

With LA as a destination, getting from place to place is quite a journey.

Isn't life a series of images that change as they repeat themselves?
—ANDY WARHOL

> *Restore human legs as a means of travel. Pedestrians rely on food for fuel and need no special parking facilities.*
>
> — LEWIS MUMFORD

Paris

The life force of any city is the millions of journeys that take place each day by the people who live there.

Paris is, above all, a walking city, and the best way of getting around is by foot. *Flâneur* is a term popularized by poet Charles Baudelaire and used to describe people who stroll the streets and boulevards in search of inspiration and sensory delights. The sidewalks belong to the pedestrians, and the roads to cars. Cars do not stop for pedestrians in Paris, so Parisians cross the street randomly, as if in an urban bullfight. It is in this milieu of urban sensuality that Parisians feel the thrill of full mastery of the city and its codes.

Bikes of all kinds compete on the roads with taxis, cars, trucks, and buses. Parisians have embraced a public bicycle sharing system called Vélib'—vél for *vélo* (bicycle) and lib' for *liberté* (freedom)—in order to move around the city quickly and easily. The buzz of scooters and motorcycles are heard everywhere in Paris, and have become a feature of the city's streets as Parisians go green and gas continues to be very expensive (double the price of gas in LA). Parisians try to look cool when moving around the city—making a style statement of their own. Every detail, from helmets and goggles to boots and straps, is extraordinarily important.

Cars are a slow and expensive means of getting from place to place in Paris. If a Parisian owns a car, it is likely to be small due to the limited available parking and heavy traffic. The most fashionable cars in Paris appear to be city runabouts like the Smart car, which originated in France. A Parisian's social status is not usually reflected by the type of car he or she

owns, although occasionally luxury vehicles can be seen on the streets of the city. While traffic in Paris is hectic, it does follow two simple rules: pedestrians do not exist and the vehicle on the right has the right of way. With its underground passages, wide boulevards, one-way streets, and roundabouts (traffic circles), the traffic moves more freely. The Boulevard Périphérique surrounding the city is the country's busiest motorway, and like everywhere in the world, it is congested during peak hours.

Beneath the city of Paris is the Métro. The distinctive Art Nouveau Métro entrances, designed by Hector Grimaud, evoke an age gone by, with elegant designs sprouting from Paris pavements. Large publicity posters, bordered by glazed ceramic frames, appear as art as they line the corridors of the stations. While on their journeys, passengers are entertained by colorful violinists and accordion players. The Paris Métro is used by almost 1.4 billion travelers each year. Its first line opened in 1900, just in time for the Exposition Universelle. Parisians immediately embraced this new form of transportation. The Métro, now a symbol of the city, covers 133 miles, has 303 stations, and includes sixteen lines, providing residents with a fast and efficient way to move around the City of Light.

Paris is also served by the Réseau Express Régional (RER) and a network of trains that run to all parts of France and Europe. There are six major train stations in the city that may be considered the true gates of Paris: Gare du Nord, Gare de l'Est, Gare de Lyon, Gare Montparnasse, Gare Saint-Lazare, and Gare d'Austerlitz, with trains going in different directions from each. Parisians and travelers alike love to take the TGV (*Train à Grande Vitesse*, or high speed train) to outlying destinations for business trips or weekend getaways. In this way, Parisians get to enjoy many destinations, and they can brag about where they have been when they return to work the following week.

And then there are the strikes. These extremely inconvenient labor disputes and their resulting demonstrations often bring the transportation system in Paris to a halt. The strikes, caused by the unions protesting one thing or another, definitely pose challenges for travelers. This has become a way of life for Parisians, who then have to consider alternative ways to move around the city. Just one more way Paris continues to provide adventure, and surprises, for everyone.

Wherever you go, go with all your heart. — CONFUCIUS

TRAIN STATIONS

Union Station, 1939

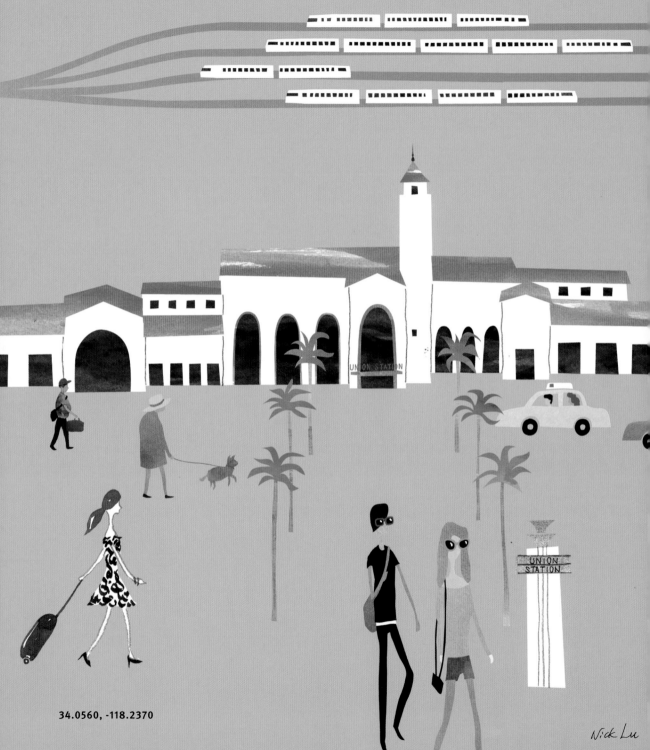

34.0560, -118.2370

Nick Lu

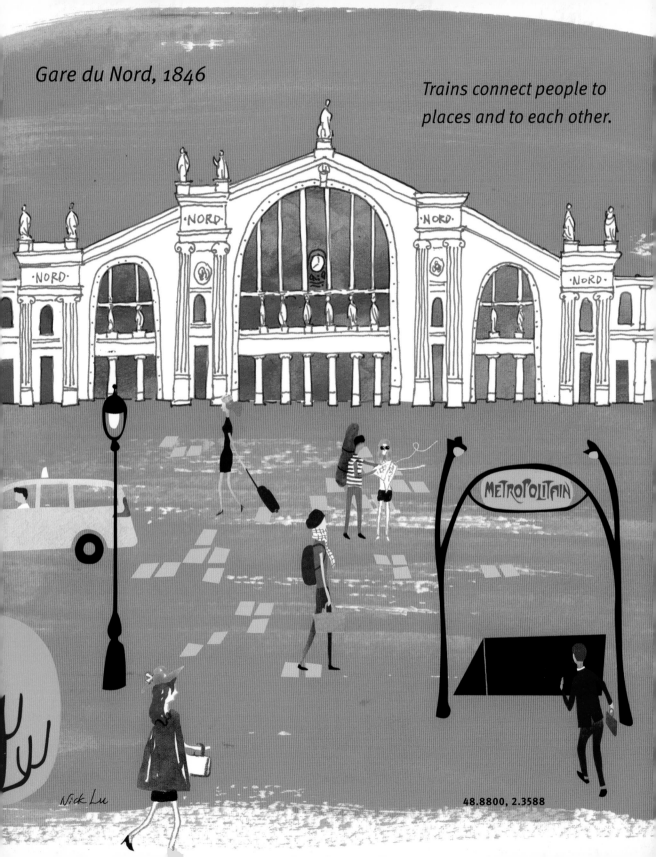

Metro, 1990

Métro, 1900

Even if you are alone in the Metro, you never feel lonely.

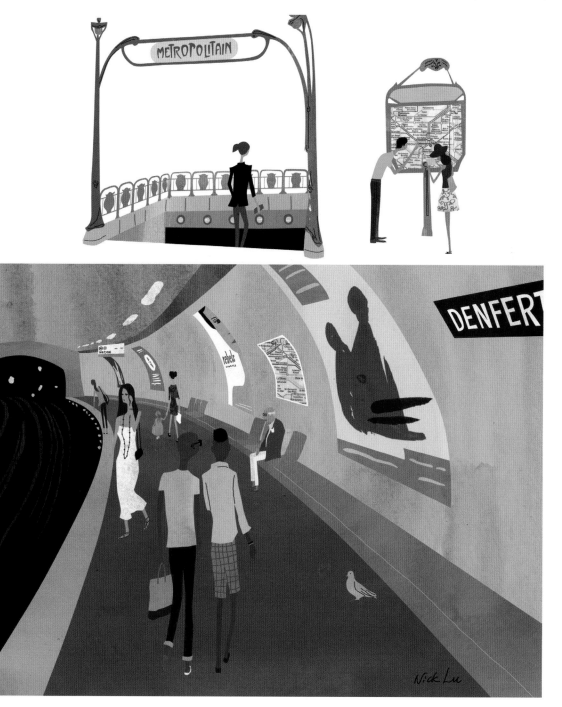

FREEWAYS & ROAD RAGE

Los Angeles, 1950s

Boulevard Périphérique, 1973

Life is too short for traffic.
—DAN BELLACK

AUTOMOBILES

Cars

Nick Lu

Voitures

Nick Lu

BICYCLES

Bikes

Nick Lu

Vélib'

The bicycle is a curious vehicle. Its passenger is its engine. —JOHN HOWARD

Nick Lu

Harley Davidson

Scooter Français

A good rider has balance, judgment, and timing. So does a good lover.

Nick Lu

CROSSING THE STREET

Los Angeles

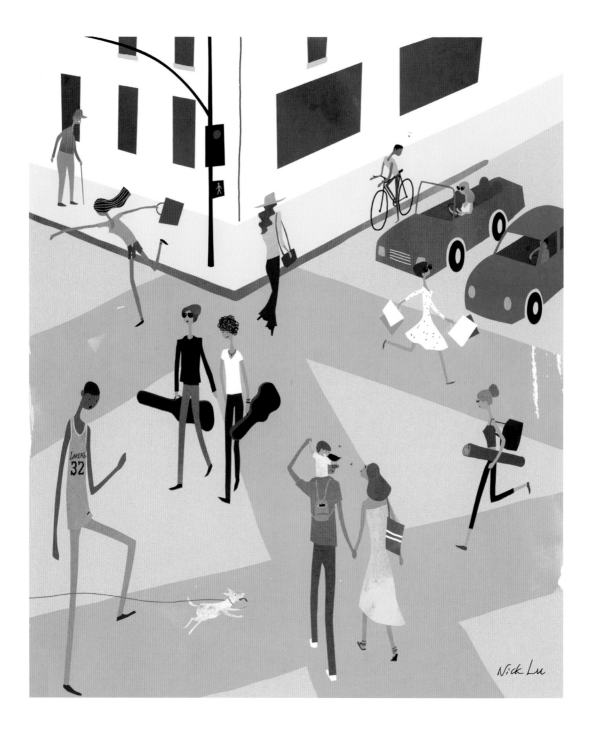

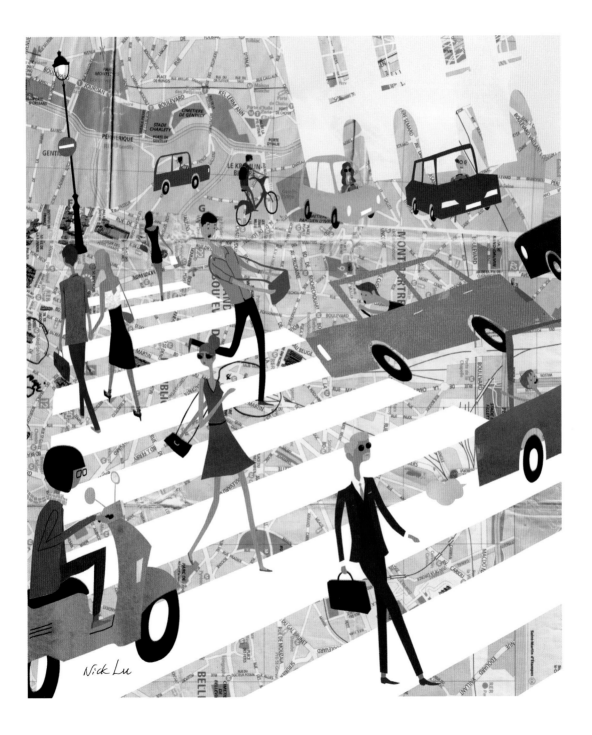

Nick Lu

Trucks

Nick Lu

Camions

Nick Lu

FUNICULARS

Angels Flight, 1901

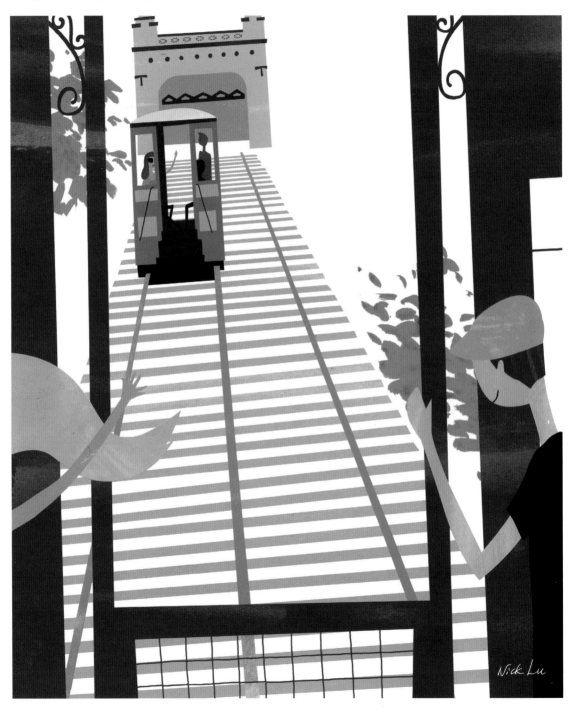

34.0514, -118.2500

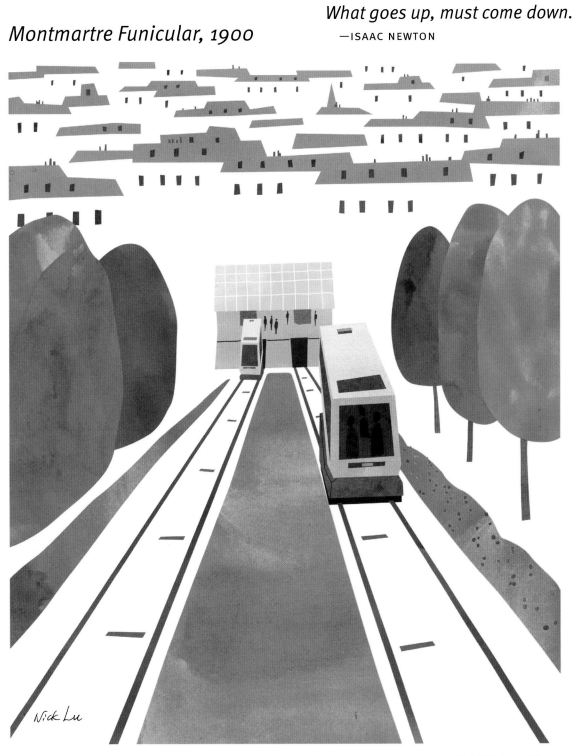

Montmartre Funicular, 1900

What goes up, must come down.
—ISAAC NEWTON

Nick Lu

48.8850, 2.3426ß

Acknowledgments

Art is a way to communicate. And for me it brings a whole array of elements together and makes something new that did not exist before.

This book of art and passion would never have existed had it not been for the spark—an idea generated by Neil C. Shaw, which compelled me to tell the illustrated story of Los Angeles and Paris. His inspiration, motivation, wisdom, expertise, and continual guidance made this book a reality and, just as importantly, a transformative experience.

Just do the things you fall in love with … you never know what's going to happen. —DAVID LYNCH

There have been many people who have helped me throughout this process and this book would not have been possible without them. Much gratitude goes to Eric Giriat and Nick Lu, whose talent and illustrations have expressed my deepest visions in a spectacular way.

Merci beaucoup to Lena and Eric Barenton, Anne (*ma fille français*) and Bertrand Jouin, Alexis "Less is More" Nolent, Al Cadosch, and Gregory Nicolaidis. I am also so grateful for these Paris collaborators, who share my love for Los Angeles and Paris, have believed in this story, and have provided continued guidance, support, suggestions, and knowledge.

Many thanks go to Norm Abbey for helping me to launch the idea, Shari Thorell for her continued support and reviews, and Dave Berkus for his encouragement to tell my story, as well as his excellent comments and contributions. Special thanks to David Ebershoff, for educating me about the publishing world and responding to my middle-of-the-night e-mails. Thanks to Jeff Sheldon for always being available with excellent legal advice. Much gratitude goes to my Pasadena Angel friends and colleagues, who have mentored me and supported

232

me in my newest entrepreneurial endeavor. Thanks to Jay Nunn and Chris Kapzynski for believing in me and helping me with my IT challenges. Much appreciation to Bruce Long for his keen insights into the creative process, his marketing skills, and his belief in the project, as well as to Rob Lindstrom for his help in teaching me what it means to be a writer. A very special thanks to Jennifer Most Delaney and her team at Benna Books in Boston for making it all come together and to Paul Norton at Ammo Books for believing in the project!

I am always grateful to Kimmy, Eric, and Michael, *mes enfants*, who have always believed in my ability to turn ideas into reality, as I have believed in theirs.

Many heartfelt thanks go to Kimmy Erin Kertes for her insightful words, talent, expertise, enthusiasm, and editorial *savoir-faire*.

Enduring gratitude for his unique contributions and ideas goes to my husband, Peter, without whom this book would not exist.

I am so very appreciative and grateful to all who have contributed something special to my life and to those who have gone out of their way to be helpful.

To all of you who said I should write a book—here it is!

What you get by achieving your goals is not as important as what you become by achieving your goals.
—HENRY DAVID THOREAU

Best Addresses |
Bonnes Adresses

Here are some of my favorite addresses in Los Angeles and Paris for shopping, restaurants, and hotels. Some are mentioned in the book, and then there are a few extras I couldn't resist sharing.

Los Angeles

RESTAURANTS

Apple Pan, 10801 W. Pico Blvd., West Los Angeles: A very popular Westside burger and pie joint from a bygone era—lots of fun.

BOA Steakhouse, 9200 W. Sunset Blvd., West Hollywood: One of the most popular steakhouses in the city.

Bouchon, 235 N. Canon Dr., Beverly Hills: Chef Thomas Keller offers casual, classic French bistro fare in this restaurant frequented by celebrities and favored by those craving great French food (that would be me!).

Café Habana, 3939 Cross Creek Rd., Malibu: Cuban classics with a New York state of mind.

Canter's Deli, 419 N. Fairfax Ave., Los Angeles: An iconic Jewish deli and favorite hangout for those who love matzo ball soup and corned beef sandwiches.

Casita del Campo, 1920 Hyperion Ave., Silver Lake: A very creative, upscale Mexican restaurant located in an edgy and hip area. Great sangria!

El Cholo, 1121 S. Western Ave., Los Angeles: One of the best and most authentic Mexican restaurants in the city. I have been going here, as well as to the Santa Monica and Pasadena locations, for a very long time.

Church & State Bistro, 1850 Industrial St. #100, Los Angeles: This restaurant, located in a budding neighborhood in an industrial part of Downtown, is very stylish and makes exquisite dishes with a modern twist on French cuisine.

Comme Ça, 8479 Melrose Ave., West Hollywood: Inspired by the brasseries in Paris, this restaurant is very popular—a crisp design and traditional French cuisine makes you think you are in Paris!

Dominick's, 8715 Beverly Blvd., West Hollywood: A charming and authentic Italian restaurant loved by LA foodies, with a sexy wine list and a beautiful brick patio!

Eveleigh, 8752 W. Sunset Blvd., West Hollywood: Inventive cocktails and an ingenious menu in a rustic setting, with excellent service and beautiful views of the city!

Father's Office, 1018 Montana Ave., Santa Monica: Universally adored for great gourmet burgers and an impressive selection of beers.

Flore Vegan, 3818 W. Sunset Blvd., Silver Lake: A vegan restaurant—cozy and inviting with vintage interiors.

Gjelina, 1429 Abbot Kinney Blvd., Venice: A favorite Italian-fusion eatery with inventive pairings and local, seasonal ingredients.

Green Street Restaurant, 146 Shopper's Lane, Pasadena: Offers a healthy, diverse menu in a charming setting, and the unmissable Dianne salad.

The Grill on the Alley, 9560 Dayton Way, Beverly Hills, and 120 E. Promenade Way, Thousand Oaks: A superb steakhouse and a favorite of those who love good food, first class service, sophistication, inventive cocktails, and wine.

Gus's BBQ, 808 Fair Oaks Ave., South Pasadena: My favorite Southern-influenced BBQ restaurant in all of LA. Great ribs, chicken, chili, burgers—everything is awesome!

Intelligentsia, 1331 Abbot Kinney Blvd., Venice: An upscale and very hip coffeehouse.

The Ivy, 113 N. Robertson Blvd., Los Angeles: Behind the white picket fence lies a lovely patio filled with celebrity diners as paparazzi linger outside. This is a great place to have lunch while shopping at the ultra-chic boutiques in the neighborhood.

Joan's on Third, 8350 W. Third St., Los Angeles: Best soup and sandwich combo in LA; a place to buy fancy pantry items and see a celebrity or two.

Katsuya by Starck, 6300 Hollywood Blvd., Los Angeles, and **Sushi Katsu-Ya**, 11680 Ventura Blvd., Studio City: The first mini-mall sushi, Sushi Katsu-Ya set the standard for great sushi and

spawned several high-end Philippe Starck–designed storefronts. Chef Katsuya is renowned for creating menu mainstays like spicy tuna on crispy rice and yellowtail sashimi with jalapeño.

La Grande Orange Café, 260 S. Raymond Ave., Pasadena: Located next to a metro station, the food and service are awesome and this is a favorite of many foodies in LA. Upscale, casual and innovative menu offerings.

LAMILL Coffee, 1636 Silver Lake Blvd., Silver Lake: The coolest coffee shop on the east side of LA. The interior is a glam mix of gilded chandeliers and faux leather chairs, and the coffee is just as elaborate.

Maximiliano, 5930 York Blvd., Eagle Rock: A fantastic Italian eatery in an up-and-coming area, featuring fresh quality ingredients in their pizzas, pastas, and specialties, in a very cool setting—great patio dining as well.

Mijares Mexican Restaurant, 145 Palmetto Dr., Pasadena: An authentic and traditional Mexican restaurant with great food, delightful service, great margaritas, and lots of fun.

New Moon, 102 W. Ninth St., Los Angeles, and 2138 Verdugo Blvd., Montrose: My absolute favorite Chinese restaurant in the city—fresh and healthy ingredients in an urban contemporary décor.

Nobu, 903 N. La Cienega Blvd., West Hollywood: Elegant and upscale Japanese cuisine by Nobu Matsuhisa in stylish surroundings. Politicos, sushi snobs, and the rich and famous all keep this restaurant on speed dial.

Osteria Mozza, 6602 Melrose Ave., Hollywood: One of the premiere Italian restaurants in LA, with a minimalist décor and gourmet food, which attracts the beautiful, upscale, and famous diners in the city—nice for a special occasion.

Parkway Grill, 510 S. Arroyo Pkwy., Pasadena: One of my favorite places to dine in Pasadena, featuring an innovative Cali-cuisine menu with local and fresh ingredients in a chic setting.

Philippe The Original, 1001 N. Alameda St., Los Angeles: One of the oldest restaurants in Los Angeles (106 years old in 2014) serves up French-dipped sandwiches. Peanuts are at every table and sawdust lines the floors of this throwback in time.

Pink's Hot Dogs, 709 N. La Brea Ave., Hollywood: Known as the best place in LA for hot dogs, as evidenced by the long lines. Entertaining and memorable.

RivaBella, 9201 W. Sunset Blvd., West Hollywood: A very chic Italian restaurant popular with the high-powered crowd.

Roscoe's House of Chicken & Waffles, 1514 N. Gower St., Hollywood: One of the first restaurants devoted to the combination of deep-fried chicken with sweet, thin waffles, a dollop of whipped butter, and maple syrup on top, Roscoe's offers up soul food that is delicious and comforting.

Rush Street, 9546 W. Washington Blvd., Culver City: This is my favorite restaurant in this up and coming, hip area. It offers comfort food and great drinks.

Spago, 176 N. Canon Dr., Beverly Hills: This is an excellent example of the culinary wizardry of

Wolfgang Puck. The year-round patio is beautiful, and the menu always features the best ingredients and haute cuisine.

Stonehaus, 32039 Agoura Rd., Westlake Village: A fantastic wine bar in a vineyard setting complete with fountains and a garden wall. Feels like the French countryside and is a great place to relax and people watch.

Tavern Restaurant, 11648 San Vicente Blvd., West Los Angeles: With a really beautiful interior and a fresh, locally sourced, Cali-cuisine menu, dining here is a real treat.

Umami Burger, 4655 Hollywood Blvd., Los Angeles: This is my favorite burger place in Los Angeles, with offerings of beef, turkey, chicken, ahi tuna, and veggie burgers bursting with the oaky, salty, and sweet umami flavor. The cheesy tots, not on the menu, are LA's version of croquettes and a must-have.

HOTELS

Andaz West Hollywood, 8401 Sunset Blvd., West Hollywood: This hotel is modern and contemporary with great city views. It is in an excellent location to walk to trendy shops and restaurants along the strip.

The Beverly Hills Hotel, 9641 Sunset Blvd., Beverly Hills: The quintessential standard of Hollywood glamour and luxury, noted for its famous pool and cabanas and lavish Polo Lounge, where the rich and famous have stayed and played. You feel transported into a bygone era—I created my own legend by getting married here.

Chateau Marmont, 8221 Sunset Blvd., West Hollywood: There is nothing quite like this eccentric and iconic hotel—it is a favorite of many celebrities. It is also always a fun place to dine and have a drink.

Hotel Bel-Air, 701 Stone Canyon Rd., Los Angeles: One of the most beautiful hotels in the city—an enchanting and magical place. I love to go here for lunch, dinner, special occasions, and even a special *petit* weekend!

Hotel Shangri-La, 1301 Ocean Ave., Santa Monica: An Art Deco masterpiece with stunning views in a great location.

The Langham Huntington, 141 S. Oak Knoll Ave., Pasadena: This is an iconic landmark and an elegant luxury resort hotel in a beautiful area of Pasadena. My friends and colleagues from France love its enchanting spa and excellent restaurants. The beautifully decorated ballrooms are venues for many special occasions and events.

Malibu Beach Inn, 22878 Pacific Coast Highway, Malibu: Surf chic design located on Carbon Beach. A great place to have a drink and catch the gorgeous sunsets.

The Millennium Biltmore Hotel, 506 S. Grand Ave., Los Angeles: This hotel epitomizes Downtown's everything-old-is-new-again scene. The 90-year-old hotel remains a timeless bastion of elegance.

The Mondrian Hotel, 8440 W. Sunset Blvd., West Hollywood: An ultra-modern, ultra-minimalist hotspot, this hotel is a place for beautiful people to come and have drinks at the sexy Skybar and people watch. The city views are stunning and it is where I take visitors when I get the chance.

Shutters on the Beach, 1 Pico Blvd., Santa Monica: Very New England colonial in its design, it is a timeless beach-house resort and an idyllic site for special occasions.

SLS Hotel at Beverly Hills, 465 S. La Cienega Blvd., Los Angeles: Designed by Philippe Starck, it is a perfect balance between comfort and style in a great, as central as can be, LA location.

The Standard Downtown LA, 550 S. Flower St., Los Angeles: Very camp with a fantastic rooftop bar.

W Hotel, 6250 Hollywood Blvd., Hollywood, and 930 Hilgard Ave., Los Angeles: Modernist, chic décor and the usual cheeky witticisms the chain is known for—a cool place to stay or have drinks.

SHOPPING

The Americana at Brand, 889 Americana Way, Glendale: An outdoor mall shopping experience with a large selection of stores, restaurants, and theaters with lots of good energy.

Amoeba Music, 6400 Sunset Blvd., Hollywood: Best record store in LA!

Barneys New York, 9570 Wilshire Blvd., Beverly Hills: Style sums it up. It showcases top avant-garde designers in women's, men's, and children's clothing, as well as high-end, hard-to-find beauty and home items.

Confederacy, 4661 Hollywood Blvd., Los Angeles: A shop where you can buy pieces of clothing that will create the indie eclectic look that is so LA, featuring women's designer and So-Cal native Rebecca Minkoff and an assortment of menswear designers.

Decades, 8214 Melrose Ave., West Hollywood: A shop for anyone who appreciates the story behind a classic piece of clothing. Decades' owners travel to estate sales throughout the world for

their fine vintage pieces. They also serve local fashionistas and consign pristine-condition contemporary threads.

Fred Segal, 8100 Melrose Ave., West Hollywood, and 500 Broadway, Santa Monica: This iconic one-stop shop is a trendsetter where you will find hip local designers and accessories.

The Grove, 189 The Grove Dr., Los Angeles: An outdoor wonderland mall with dancing fountains, a great selection of shops, restaurants, and theaters, and lots of fun.

Kitson, 8590 Melrose Ave., West Hollywood: A go-to boutique for trendy pop culture–inspired clothing and accessories, frequented by some very famous customers.

Madison, 3835 Cross Creek Rd., Malibu (and other locations as well): These stores capture the indie spirit of LA style—creative and quirky.

Monique Lhuillier, 8485 Melrose Place, Los Angeles: A shop to go to if you need a beautiful gown or special-occasion clothing for a glamorous event—a great place to indulge in fantasy.

Neiman Marcus, 9700 Wilshire Blvd., Beverly Hills: A luxury brand department store featuring top designers.

Nordstrom, locations throughout the city: This department store is a favorite for its fantastic mix of brands, styles and service.

Saks Fifth Avenue, 9600 Wilshire Blvd., Beverly Hills: Although headquartered in New York, this luxury-goods retailer also makes a bold statement in Los Angeles.

Stacey Todd, 13025 Ventura Blvd., Studio City, and 454 N. Robertson Blvd., West Hollywood: A Valley gem—owner Stacey Todd curates her high-end women's store with a masculine, modern, rock 'n' roll edge.

TenOverSix, 8425 Melrose Ave., Los Angeles: An indie, eclectic mix of merchandise—a go-to shop for edgy and interesting pieces to mix with casual chic, vintage, and tailored clothing.

Third Street Promenade, between Wilshire Blvd. and Broadway in Santa Monica: A great place to spend an afternoon shopping in many fine stores just a few blocks from the beach.

THVM Atelier, 1317 Palmetto St., Los Angeles: A retail store located in a hip area in the downtown Arts District that includes an edgy range of ready-to-wear and couture labels—a memorable shopping experience.

Trina Turk, 8008 W. 3rd St., Los Angeles: Based in Palm Springs and LA, the designer's bright prints and eclectic and pop-art-inspired combinations will always make you smile.

Vroman's Bookstore, 695 E. Colorado Blvd., Pasadena: The best, and largest, independent and family-owned bookstore in the city—you can always find what you want. They have lots of events and book signings, and a very literary and artistic crowd meets here.

The Way We Wore, 334 S. La Brea Ave., Hollywood: This fantastic store is filled with incredible vintage gowns, accessories, and items that serve as inspiration for designers.

Paris

Angelina, 226 Rue de Rivoli, 75001: Beautiful tearoom with gorgeous ceilings, exquisite furnishings, and fabulous, fluffy cakes.

Apicius, 20 Rue d'Artois, 75008: Glamorous décor and service and sensational cuisine.

239

L'Avenue, 41 Avenue Montaigne, 75008: Light and healthy cuisine—and the interior is designed in my favorite color, violet. This is a popular meeting place for celebs and journalists.

Bar Du Marché, 53 Rue Vieille du Temple, 75004: Great café located in the center of the Marais and all the best shopping—terrific service and value.

La Bastide Blanche, 1 Blvd. de Courcelles, 75008: An upscale Parisian brasserie that has a French menu with a twist and a cool artistic vibe. It was the setting for many meetings with this book's French illustrator, Eric Giriat.

Bofinger, 5–7 Rue de la Bastille, 75004: Incredible Art Nouveau interior—seafood, sausages, and celebrities.

Bon, 25 Rue de la Pompe, 75116: An upscale and beautifully designed restaurant by Philippe Starck, featuring a healthy, light cuisine.

Bouillon Chartier, 7 Rue du Faubourg Montmartre, 75009: Good French fare in an authentic and lively environment. Opened in 1896, it is an official historical monument.

Brasserie Balzar, 49 Rue des Écoles, 75005: No visit to Paris is complete without a stop here. An Art Deco masterpiece with a classic French menu—originally a meeting place for intellectuals and now a very popular restaurant.

Brasserie Lipp, 151 Blvd. Saint-Germain, 75006: This Hemingway haunt has a spectacular Art Deco interior, classic French cuisine, and waiters with attitude.

Brasserie Thoumieux, 79 Rue Saint-Dominique, 75007: Beautiful interior and a classic French menu with style.

Café de Flore, 172 Blvd. Saint-Germain, 75006: A historic café and meeting place for artists and writers.

Café Louise, 155 Blvd. Saint-Germain, 75006: This restaurant has the best burger in Paris—a must! Great French fare with a flair as well.

Café Marly at the Louvre, 93 Rue de Rivoli, 75001: Spectacular location with a view of the Louvre.

Chez Fernand, 13 Rue Guisarde, 75006: In the heart of Saint-Germain, a classic French bistro with red-and-white checkered tablecloths. This is a great place to meet for lunch; I often meet my friends in the design business here.

La Coupole, 102 Blvd. du Montparnasse, 75014: Magnificent Art Deco dining room with classic Parisian brasserie food; full of bustle.

Cristal Room Baccarat, 11 Place des États-Unis, 75116: Designed by Philippe Starck, the ambience is *très* chic and they have a great wine list.

Dino, 8 Chaussée de la Muette, 75016: My favorite Italian restaurant in Paris—best pizzas, pastas, and salads.

Frenchie, 5–6 Rue du Nil, 75002: Fabulous food, cool vibe, great service, and great wines. Lots of fun—a must!

La Gare, 19 Chaussée de la Muette, 75016: A train station converted into a spectacularly designed restaurant, with a fantastic menu offering prix-fixe options.

Gaya Rive Gauche, 44 Rue du Bac, 75007: A fantastic modern seafood restaurant with fresh fish and unique specialties only found here. Their exceptionally light preparation of fish is delightful.

Le Georges at the Centre Pompidou, 19 Rue Beaubourg, 6th floor, 75004: A fantastic view of the city with a contemporary architectural flair.

Le Grand Bistro de la Muette, 10 Chaussée de la Muette, 75016: The best value in Paris, with a prix-fixe menu, elegant décor, and outstanding service.

Le Jules Verne at the Eiffel Tower, Avenue Gustave Eiffel, 75007: Incredible view of Paris and luxury dining—very romantic and special!

Ladurée, 16 Rue Royale, 75008: My favorite tearoom in Paris. The macarons are addictive and make great gifts.

Ma Bourgogne, 19 Place des Vosges, 75004: A favorite of mine in the Marais, amidst all the art galleries; a typical French menu and a view of the beautiful Place des Vosges.

Mariage Frères, 30–32 Rue du Bourg-Tibourg, 75004: Best selection of teas anywhere. I love the salads and cakes.

Market, 15 Avenue Matignon, 75008: Elegant and stylish—distinctive fusion cuisine.

Les Ombres at the Musée du Quai Branly, 27 Quai Branly, 75007: A fantastic bar with a great view of the Eiffel Tower.

La Pâtisserie des Rêves, 111 Rue de Longchamp, 75016: This pâtisserie of dreams takes an artful approach to cakes and classic baked goods—beautiful, unusual, and a great place to have a morning pastry.

Silencio, 142 Rue Montmartre, 75002: A private club and meeting place for artists, writers, and creative types, designed by David Lynch. This is my favorite place to go for drinks, cinema, lectures, and music—very inspirational.

Spoon, 14 Rue de Marignan, 75008: This Ducasse- and Starck-inspired restaurant is a favorite of mine for its outstanding fusion fare that you can mix and match.

HOTELS

Le Bristol Paris, 112 Rue du Faubourg Saint-Honoré, 75008: Located in the best shopping area of Paris and featured in Woody Allen's movie, *Midnight in Paris*.

Le Citizen Hotel, 96 Quai de Jemmapes, 75010: Understated design with canal views, located in an area filled with a new generation of chic cafés, shops, and restaurants.

Four Seasons Hotel George V, 31 Avenue George V, 75008: One of the top addresses in Paris and one of the finest hotels in the world. This is one of the best places to experience the spirit of French luxury.

L'Hôtel, 13 Rue des Beaux-Arts, 75006: In the heart of Saint-Germain, this is a very small and special boutique hotel with an interior designed by Jacques Garcia.

Hôtel Bel-Ami, 7–11 Rue Saint-Benoît, 75006: Located in the heart of Saint-Germain—very stylish, urban chic, and comfortable. This is where I used to stay before I had a flat in the city.

Hôtel Costes, 239–241 Rue Saint-Honoré, 75001: This hotel, with its popular bar and courtyard restaurant, is a meeting place for beautiful people.

Hôtel d'Angleterre, 44 Rue Jacob, 75006: A charming hotel in Saint-Germain with a rich history (Hemingway stayed here).

Hôtel du Nord, 102 Quai de Jemmapes, 75010: An atmospheric hotel on the Canal Saint-Martin; edgy with a hipster vibe and famous for Marcel Carné's movie masterpiece *Hôtel du Nord*.

Hôtel du Petit Moulin, 29–31 Rue de Poitou, 75003: Christian Lacroix converted what was once a *boulangerie* (bakery) into one of the quirkiest hotels in Paris. Quite the design hotel, here you experience haute couture as a lifestyle.

Hôtel Plaza Athénée, 25 Avenue Montaigne, 75008: An elegant and luxurious hotel, Ducasse's restaurant and bar make it one of the city's most talked about places. The magnificent exterior has flowers everywhere, making it charming and glamorous. This hotel often appears in TV shows and movies.

Hôtel Récamier, 3 bis Place Saint-Sulpice, 75006: A luxurious boutique hotel near Saint-Sulpice, where you can follow the trail of Dan Brown's novel *The Da Vinci Code*.

Pavillon de la Reine, 28 Place des Vosges, 75003: The nicest hotel in the Marais, located on the beautiful Place des Vosges. A mix of old and new, it is a secret hideaway surrounded by some of the best art galleries in Paris.

Pershing Hall, 49 Rue Pierre Charron, 75008: Hidden discreetly behind a classic Paris façade is a courtyard with a lush vertical garden, making this hotel a very special retreat.

Le Royal Monceau—Raffles Paris, 37 Avenue Hoche, 75008: Another Starck masterpiece, and an artist's heaven—very, very stylish.

Shangri-La, 10 Avenue d'Léna, 75116: Quite the luxury hotel and spa with gorgeous views of the city and excellent dining rooms and bars, which makes this one of my personal favorites to enjoy with a crowd.

Androuët, 37 Rue de Verneuil, 75007: The best place in Paris for those who love cheese—over 200 different selections!

Antoine et Lili, 95 Quai de Valmy, 75010: A very boho shop full of irresistible fashions and accessories, located on the very cool Canal Saint-Martin.

Azzedine Alaïa, 7 Rue de Moussy, 75004: Identified by a small bell on the exterior, the shop interior is fantastic and filled with gorgeous creations in figure-hugging styles.

BHV (Bazar de l'Hôtel de Ville), 52 Rue de Rivoli, 75004: A complete and functional department store in the Marais, just across the street from the Hôtel de Ville, Paris' city hall. This store has everything you would ever need. The hardware store in the basement alone has more product offerings than a whole Home Depot! This is the only place in Paris where I can find whatever it is I am looking for.

Le Bon Marché, 24 Rue de Sèvres, 75007: The oldest department store in Paris—very elegant and the food halls are incredible.

Chanel, 31 Rue Cambon, 75001: Headquarters of the Chanel empire where Coco began her *atelier*; it remains largely similar to the way it was in her time. I make a point to purchase my Coco perfume here.

Charabia, 11 Rue Madame, 75006: The ultimate fashion destination for girls and young women.

Lena Barenton's designs are irresistible and favorites of celebrities.

Christian Louboutin, 38–40 Rue de Grenelle, 75007: The red leather sole—to own a pair is every woman's dream!

Colette, 213 Rue Saint-Honoré, 75001: This is my go-to place to discover trends—a pioneer concept store with carefully selected fashions, shoes, design, books, cosmetics, electronics, jewelry, and accessories.

Comptoir des Cotonniers, 124 Rue Vieille du Temple, 75004: Women's collections that combine modernity with timeless chic in an intimate and luminous atmosphere.

Diptyque, 34 Blvd. Saint-Germain, 75005: The best candles in Paris. The figuier scent is my favorite.

Galeries Lafayette, 40 Blvd. Haussmann, 75009: The most famous department store in Paris—known best for its gorgeous interior dome. Incredible shopping made up of three huge buildings where you can find most anything. I spend lots of hours, and money, here. There is a fantastic view from its rooftop terrace.

Hermès, 24 Rue du Faubourg, Saint-Honoré, 75008: Known for its fabulous leather articles, accessories, silk scarves, and ties, the Kelly and Birkin bags have become cult objects—exquisite interior and design.

243

La Hune, 18 Rue de l'Abbaye, 75006: One of the leading bookstores in Paris. This is a favorite place to meet and to browse for hours. Many of the references I used to write this book were purchased here!

Isabel Marant, 16 Rue de Charonne, 75011: One of the best designers in Paris—wearable designs with an ethnic touch. This shop is fantastic.

The Kooples, 191 Rue Saint-Honoré, 75001: Inspired by men and women borrowing each other's styles, the clothes here have a unisex feel—always chic and fantastic quality.

Longchamp, 404 Rue Saint-Honoré, 75001: My favorite brand for beautiful leather accessories—classic, timeless, elegant, and high quality with a deeply rooted equestrian history.

Louis Vuitton, 101 Avenue des Champs-Élysées, 75008: Luxury boutique that showcases the splendid fashion and accessories for which the brand is known worldwide.

La Maison du Chocolat, 52 Rue François 1er, 75008: The best handmade chocolates—the display windows are full of temptation and the truffles are worth the sin.

Maje, 42 Rue du Four, 75006: Slightly quirky and always cutting edge, Maje is feminine and bold, with must-haves each season.

Merci, 111 Blvd. Beaumarchais, 75003: A concept store where you can find books, home design, fashion accessories, and espresso.

Les Petites, 10 Rue du Four, 75006: The perfect representation of the chic Parisian look with work-appropriate basics and classic takes on runway trends.

Poilane, 8 Rue du Cherche-Midi, 75006: The best bread in Paris is baked here—an unforgettable experience.

Printemps Haussmann, 64 Blvd. Haussmann, 75009: A beautiful, upscale, grandiose, kitsch department store with a fantastic selection of brands, products, and services. The window displays are incredibly creative.

Sandro, 50 Rue Vieille du Temple 75004: Special, feminine, and distinctly French clothes for women—revisited classics with a chic edge for men.

Spree, 16 Rue la Vieuville, 75018: An unusual boutique filled with young fashion designers—a place to discover new designs and designers.

Surface to Air, 108 Rue Vieille du Temple, 75003: Showcases fashion, art, and design—a great place to check out new trends.

References

Bertinetti, Angela and Marcello Bertinetti. *Paris*. New York: Gallery Books, 1986. Print.

Berts, Jean-Michel. *The Light of Paris*. New York: Assouline Publishing, 2006. Print.

Boespflug, Barbara and Beatrice Billon. *Paris fait son Cinéma*. Paris: Hachette Livre Éditions du Chêne, 2012. Print.

Brooks, Jason. *Paris Sketchbook*. London: Laurence King Publishing, 2013. Print.

Dailey, Donna and Mike Gerrard. *DK Eyewitness Top 10 Travel Guide: Paris*. New York: Dorling Kindersley Limited, 2012. Print.

Dickey, Jeff. *The Rough Guide to Los Angeles and Southern California*, 2nd Edition. London: Rough Guides, 2011. Print.

Essers, Volkmar. *Matisse*. Köln: Taschen GmbH, 2006. Print.

Gautrand, Jean Claude. *Paris: Portrait of a City*. Köln: Taschen GmbH, 2012. Print.

Gerber, Catherine. *DK Eyewitness Top 10 Travel Guide: Los Angeles*. New York: Dorling Kindersley Limited, 2012. Print.

Glaeser, Edward. *Triumph of the City: How Our Greatest Invention Makes Us Richer, Smarter, Greener, Healthier, and Happier*. New York: Penguin, 2011. Print.

Gould, Lark Ellen. *Los Angeles Off the Beaten Path*, 2nd Edition. Guilford, CT: The Globe Pequot Press, 2005. Print.

Hofstede, Geert, Gert Jan Hofstede, and Michael Minkov. *Cultures and Organizations: Software of the Mind*, Third Edition. New York: McGraw-Hill, 2010. Print.

Honnef, Klaus. *Andy Warhol, 1928–1987: Commerce into Art*. Köln: Taschen GmbH, 2000. Print.

Kidder, Tracy and Richard Todd. *Good Prose: The Art of Nonfiction*. New York: Random House, 2013. Print.

Klingsöhr-Leroy, Cathrin. *Surrealism*. Köln: Taschen GmbH, 2004. Print.

Knopf Guide: Restaurants of Paris. New York: Alfred A. Knopf, 1994. Print.

Knopf MapGuide: Los Angeles. New York: Alfred A. Knopf, 2010. Print.

Koch, Jared. *Clean Plates Los Angeles 2013: A Guide to the Healthiest, Tastiest, and Most Sustainable Restaurants for Vegetarians and Carnivores*. Fort Lee: Clean Plates, 2012. Print.

Kolossa, Alexandra. *Keith Haring*. Köln: Taschen GmbH, 2009. Print.

Laurent, Jacques and Hervé Champollion. *Vivre Paris*. Fellbach: Edition Axel Menges, 1987. Print.

Lebovitz, David. *The Sweet Life in Paris: Delicious Adventures in the World's Most Glorious—and Perplexing—City*. New York: Broadway Books, 2011. Print.

Long, Dixon and Marjorie R. Williams. *Markets of Paris*, Second Edition. New York: The Little Bookroom, 2012. Print.

Lynch, David. *Catching the Big Fish: Meditation, Consciousness, and Creativity*. New York: Tarcher/Penguin, 2006. Print.

Magny, Olivier. *Stuff Parisians Like: Discovering the Quoi in the Je Ne Sais Quoi*. New York: Berkley Books, 2011. Print.

Magsaysay, Melissa. *City of Style: Exploring Los Angeles Fashion, from Bohemian to Rock*. New York: It Books, 2012. Print.

Muratyan, Vahram. *Paris versus New York: A Tally of Two Cities*. New York: Penguin Books, 2012. Print.

Ollivier, Debra. *Entre Nous: A Woman's Guide to Finding Her Inner French Girl*. New York: St. Martin's Griffin, 2004. Print

Péchiodat, Fany, et al. *My Little Paris*. Paris: Éditions du Chêne, 2011. Print.

Price, Steven D. *1001 Smartest Things Ever Said*. Guilford, CT: Lyons Press, 2005. Print.

Robertson, Nichole. *Paris in Color*. San Francisco: Chronicle Books, 2012. Print.

Robinson. *Paris, Line by Line*. New York: Rizzoli, 2013. Print.

Schwaab, Catherine. *Fashion mode d'emploi*. Paris: Flammarion, 2010. Print.

Sieg, Caroline. *Discover Paris*. Lonely Planet, 2011. Print.

Skolnick, Adam. *Pocket Los Angeles*. Lonely Planet, 2012. Print.

Stanford, Emma. *Fodor's Los Angeles' 25 Best*. New York: Fodor's Travel, 2012. Print.

Stanic, Borislav. *Los Angeles Attractions*. Beverly Hills: Museon Publishing, 2008. Print.

Starr, Kevin and David L. Ulin. Jim Heimann, ed. *Los Angeles: Portrait of a City*. Köln: Taschen GmbH, 2009. Print.

Stone, Andrew. *A Hedonist's Guide to Los Angeles*. London: Hg2, 2009. Print.

StyleCity Paris. New York: Harry N. Abrams, 2003. Print.

Taschen, Angelika. *Taschen's Paris*. Köln: Taschen GmbH, 2008. Print.

Wallpaper City Guide Los Angeles. London: Phaidon, 2011. Print.

Wallpaper City Guide Paris. London: Phaidon, 2011. Print.

Wilkman, Jon and Nancy Wilkman. *Los Angeles: A Pictorial Celebration*. New York: Sterling Publishing Co., 2008. Print.

Winkler, Susan Swire. *The Paris Shopping Companion*, Third Edition. Nashville: Cumberland House Publishing, 2002. Print.

Yoon, Joy. *The Best Things to Do in Los Angeles: 1001 Ideas*. New York: Universe, 2013. Print.

Profile of the Author

DIANE RATICAN received her bachelor of arts degree in History and Sociology from the University of California Berkeley, and then earned her master of arts degree in Sociology and Education from UCLA. She started her career educating gifted children, and then moved on to become a risk-taking entrepreneur. This background uniquely prepared her to engage in this latest endeavor, as writer, conjuror of images, and artistic director. Her vision of art telling a story comes from her innate creativity and her talent as a collector and curator of art. To her, educating is communicating, and that is what she strives for in *Why LA? Pourquoi Paris?* Sharing her enchantment with, and knowledge of, both Los Angeles and Paris has become a complex project with all the depth and nuances of a richly textured tapestry. Her drive is what has navigated her through this process.

As an entrepreneur, Ratican built a highly successful business importing children's clothing from France for upscale retailers across the US. This challenging corporate venture allowed her to continue her love affair with Paris. Ratican's excitement for and infatuation with Paris, her second home, plus her enthusiasm for her resident city, Los Angeles, uniquely positions her to engage readers to develop their own love affair with both of these dynamic destinations.

Ratican approached this distinctive book just as she approaches all of life's challenges: with passion, tenacity, attention to detail, drive, and a joyful exuberance to create something inimitable and meaningful. Ratican is a devoted wife, mother, and grandmother, and she lives in Pasadena, California.